INTRODUCTION

VIDEO HOME MOVIES:
THERE'S MORE
THAN MEETS THE LENS

Not a bad idea. But it will never catch on. Did I really say that?

I'd like to think it was just the heat poaching my brain when I try now to fathom my response to the world's first portable, color video camera. Smirking and snickering between gulps of free pigs-in-blankets, I saw the thing with a dozen or so other reporters on the electronics beat, shoehorned into a small, smoky room in Chicago's old Conrad Hilton Hotel. The date was June 5, 1979.

Somebody representing the manufacturer Akai was demonstrating a new gadget called Activideo—a video camera that was propped on his shoulder like a bazooka. The camera was attached to a portable VCR, slung like a suitcase over the poor guy's slumping shoulder. The demonstrator said, "Now, for the first time, parents will be able to make home movies on videotape."

At which point I turned to a colleague, as he's never since let me forget, and said that no parents on earth would ever lug around a TV-studio-in-a-bazooka just for their kids—and that no kids would ever tolerate having the thing waved in their faces.

Who could have known?

Until that day, I had rarely conceived of TV as a medium in which anything

1

remotely expressive, creative, or motivational could be achieved by individuals, let alone by kids or families as a unit. On the contrary, like most people I knew, I had always tended to expect the worst from video. I had read George Orwell's *1984*. I knew how video cameras were supposed to end up peering down at us from everywhere, hung up on lampposts and hidden in the homes of people who'd been rendered powerless by the electronic eye.

Yet by the real-life *1984*, something pretty unpredictable had happened: Instead of one central power employing video to watch over all of us, we were using video to watch ourselves. Now we're all running around pointing video cameras at one another. It's *1984* turned inside-out.

What happened? Something went right. Video turned out to be a tool of liberation from conventional, mass-oriented TV. Rather than passively absorbing network programming, families have been buying up the various new home-video products to use the TV set for increasingly varied, active and creative purposes. Sure, we still watch horrifying proportions of network TV; but we've also gotten accustomed to renting movies, recording and building libraries of favorite programs to watch with VCRs and, more and more, shooting our own movies on home video.

Electronic motion-picture cameras are becoming the Brownies of the video age—perfectly "high-tech," sophisticated and pricey for families in the computer-operated, credit-card world. Growing up today, my kids think it's normal to see themselves on TV. And it is. Thanks largely to home video, the TV screen is finally beginning to lose the mystique that has long made whoever appears on it seem so much larger than life. Being on TV is now a part of everyday life for families with video cameras.

Moreover, home video offers unusual potential for families to benefit in a wide variety of important ways. There's more to home movies than meets the lens, and that's what *How to Shoot Your Kids on Home Video* is about. This is an exploration of the virtues and the liabilities of video moviemaking, for parents who want to get the most out of video to the enrichment, the enlightenment, and the entertainment of their families. Unlike the covertly promotional or highly technical material found in owner manuals, advertisements, sales brochures and esoteric publications, *How to Shoot Your Kids on Home Video* has been researched and written to meet the needs of conscientious parents with valid concerns, questions and ambitions about home moviemaking.

How to Shoot Your Kids on Home Video isn't meant to sell or promote anything—not even the basic idea of home moviemaking. Personally, I love making movies, and I hope my feelings on the subject come through. Yet the intention here is to help you see the pastime objectively, from a real-

world perspective, through criticism, commentary, facts, and a little humor, to allow your family to make the best video movies it can.

The book is organized linearly, to a degree: It begins with the rudiments, and it ends with a section intended for those who have a good grasp of how to make home movies. In-between, there are five sections organized by theme, on different aspects of moviemaking.

Section I, "The Basics," addresses those issues which should be considered before beginning a movie—in fact, before buying a camera. For instance, how do kids feel when they're in front of the camera? When are the best— and the worst—times to tape? What if a child doesn't like to be photographed? Why is it that so many home movies are so unbearable to watch? What should you know about your camera?

Section II covers the four most common home-moviemaking situations: special occasions, slices of life, stories, and sports. How can moviemakers see beyond the obvious when shooting the most popular types of movies, so as to make better movies as well as better children? Section III, "On Location," details the hazards and the benefits of shooting both outdoors and indoors, to help parents anticipate and avoid some serious problems.

For both parents and teachers, Section IV, "Learning with Home Movies," examines the educational value of moviemaking for children from pre-school age through adolescence. In addition, the section provides step-by-step guidelines for a variety of video learning projects, geared specifically for children in each of four basic age groups.

Some "Special Stuff" and "A Little Tech" follow in Sections V and VI, for those who've reached somewhat advanced stages of moviemaking. Topics include special effects, editing, the use of accessories such as lights and filters, and nuts-and-bolts tips on averting damage to, and unnecessary wear and tear on, electronics equipment.

Finally, Section VII offers a selection of full shooting scripts, ready for the whole family to use, including such backyard blockbusters as *Kids from Space* and *The Homewrecking Game*. In addition, there's a glossary of home-moviemaking terms at the back of the book for ready reference.

No one needs any experience with a video camera to start reading *How to Shoot Your Kids on Home Video*. In fact, the book is intended to be valuable to anyone who might be just considering getting involved in home movies, as well as recent purchasers of video equipment, *and* old hands at home-moviemaking. The main idea is that the more you know about home movies, kids, and how they affect each other, the better you can do as both a moviemaker and a parent.

I

THE BASICS

1

PLAYING PARTS:
YOUR FAMILY MEMBERS AS HOME MOVIE STARS

Of all the particulars involved in making home movies, there's only one thing that will always stay essentially the same: your "cast." As the principal subject matter of most of your movies, your family will always remain the one part of your productions that you can't rewrite, throw away or return to the manufacturer, though you'll certainly consider these options for certain members of your family at various times in the moviemaking process.

Your personal cast of household performers will appear in virtually every one of your movies, whatever the setting or occasion, year after year. In a sense, then, the whole family will become something like an Old World repertory troupe or, more accurately, like the cast of nut cases on "Saturday Night Live." Young and unseasoned, they go out in front of the camera and wing it *live*, with no retakes.

How can you help your own cast? What's your responsibility to the kids as the family moviemaker? For starters, it's critical to consider every one of the individuals involved in your home-movie projects. Neither favor nor neglect any particular members of the family, regardless of how photogenic, outgoing or talented they may or may not be. Divide on-camera time as you would your own time at play with each of the kids. In fact, it's a useful device to keep a running tally of the approximate amount of time everyone spends on-camera, either mentally or on a scratch sheet.

Age is definitely a key consideration here. Unfortunately, parents tend to shoot most of their movie footage, like most of their still photos, when their first kids are in their earliest years. There are two clear reasons for this: for one, parents usually buy the camera when the first child is born, so both the equipment and the child carry the excitement of something new in the house. That's why Kodak and Polaroid profits soared during the baby-boom years of the mid '50s, much as the electronics companies which make camcorders are now booming in these days of the baby boomers' own baby boom.

Secondly, we tend to think of babies as cuter than older kids, although a comparison of the photos of any two human beings at the ages of one week and five years will almost certainly disprove this theory. But cuteness should have absolutely no place in deciding when to record footage of your children for posterity. Every parent should realize this.

So, it's the conscientious parents' responsibility to fight these tendencies to favor both first children and younger children on film and tape. Meanwhile, kids have their own ideas about when they want to be in home movies, and these are also related to age. The issue involved is ego development, or the Calvin Klein Factor. In other words, the degree to which a child will behave naturally in a home movie decreases in direct proportion to age and/or that child's affinity for Calvin Klein sportswear. As a newborn, when the average person's preference for attire is dictated by how much the label itches, as opposed to how it reads, he or she will tend to behave perfectly naturally before the camera. But, as the years progress and the ego develops, children become increasingly self-conscious of their public images and commensurately self-conscious in front of the camera. The phenomenon usually peaks at adolescence, when kids want nothing whatsoever to do with home movies or with any garment not manufactured by Calvin Klein.

What's the best way to deal with the problem? How do you handle someone who simply can't stand to be photographed?

I've had some vivid experience with the problem. My own sister always hated to be photographed, so I kept my video camera clear of her out of respect (and fear of her wrath). Sadly, she died without warning a year after I started to videotape, so that I haven't a single second's footage of her. I regret the lack deeply now. But at the time, like so many home moviemakers, I wasn't certain how to deal with a family member's anxiety.

What I've learned over the subsequent years is that the camera has mysterious powers, indeed. All those primitive cultures that believe photographic images steal people's souls are correct. Because of the camera's unique ability

to capture and display us in the presence of others, it "taps the core of our self-image," says Dr. Elayne Kahn, a New York-based psychiatrist and the author of *1,001 Ways You Reveal Your Personality.*

"When a child doesn't want to be taped, that child probably thinks he's unattractive, which is to say the child feels inadequate," Dr. Kahn explained to me. "It's a fairly common problem, although it's not a difficult one to resolve. What the parent should do is draw attention away from the child's appearance and focus instead on his or her abilities.

"In other words, tell the child you want to tape him in a particular activity that he's good at and proud of, such as playing ball or reading aloud. But don't talk about showing the tape to others. Later, when you play the tape back, mention that the kid looks wonderful, without overdoing it. Keep your reinforcement positive and focused."

Later, we'll talk more about how to bring out people's individual strengths in home movies. Meanwhile, remember that a child's passion for the camera can be as problematic as his or her dread of it. When a youngster insists upon dominating every scene in every movie you make, his or her self-image might be overly advanced. Having a mini-Madonna in the house can be just as troublesome as having a pint-size Sean Penn.

As I said, try to videotape everyone in rough proportion to the amount of time you spend together *off-camera.* And apply this approach to *all* the people in your daily life, not just to your immediate family. This way, your movies will become a rich and vivid microcosm of your family's life at a point in your personal history.

Think about your own childhood. What did you do every day? Who were your best friends? Now, picture your parents' family photo album or super-8 home movies. Who's in them? Are they the same faces you see in your fondest memories?

Probably not. In my family, for instance, we have boxes and boxes of photo albums and 8-mm film reels. My father-in-law Stan even has a beautiful black-and-white home movie of his own bar mitzvah in the early '40s. Unfortunately, he doesn't recognize the vast majority of people in the film; they're almost all distant relatives with whom he had barely ever spoken. That movie is the only film my father-in-law has of his youth, and there's hardly a soul in it who played a memorable part in his life.

Meanwhile, Stan loves to tell my family colorful tales about his childhood in Brooklyn, when apartment-house doors were never locked and his mom cooked up bass he caught from the clean, clear East River while fishing with

his childhood buddy Alvie Toffler (the author). Now, *that's* the stuff I would really love to watch in my in-laws' home movies, if only to see how all those colorful tales hold up in "black-and-white."

When you're shooting your own children, try to catch them in the company of the friends with whom they usually spend most of their time. Include all the neighborhood kids you might be sick of seeing in your house, as well as the out-of-town cousins who come to visit once a year. Moreover, don't slip into the trap of forgetting to shoot your own adult friends and yourselves—including whoever does the family camera work. Make sure at least two people in the family feel comfortable with the video camera, so no one becomes chronically relegated to the unseen side of the lens.

Once you're ready to start rolling tape, you have a range of important responsibilities to your cast of family and friends. Foremost, you ought to do your best to make them look *their* best. "The best thing you can do as a director is to bring out the best in your cast," David Wilson, the longtime director of "Saturday Night Live," told me. "So think about who's in your movie. Think about what it is that makes them special. What is it about your particular child or children that is different from every other child? What are your kids' strengths and weaknesses? Try to bring out those strengths and play down the weaknesses."

Ask yourself: Does anyone have any physical traits that he or she might want you to bear in mind, for better or worse? You might go so far, providing you have the charm to pull it off, as to ask people in private if they want you to consider anything special about their looks.

In the event that you need to accommodate certain individuals' physiological idiosyncrasies, here are a few tips:

Weight: Resist full-body shots and profiles. Three-quarter angles are best. Light backgrounds help.

Height: Shoot from below eye-level to increase, above eye-level to diminish, height. Refrain from pairing the person with others who might serve to accent the height issue.

Facial features: To attenuate problems with a nose, chin, complexion, or other features, shoot from a moderate distance. Avoid profiles. Never use a wide-angle lens. In extreme instances, use soft lighting, a "soft-focus" or "haze" filter, or even a very, very light coat of clear petroleum jelly spread evenly on the surface of your lens. (Don't worry; it won't damage your lens if applied carefully and removed promptly.)

Voice: Nasal, sibilant and high-pitched vocal tones are exacerbated by weak or noisy recording techniques. Try a wireless microphone for close, direct recording of a problem voice. With such a wireless set-up, a tiny mike clips onto the clothing of the subject, transmitting signals to a small receiver which attaches to the top of the video camera.

Aside from physical virtues and liabilities, individual temperaments and abilities also merit your attention as a home moviemaker. Everybody has something special—a lovely smile, a keen sense of humor, musical talent, mechanical ability, brains . . . a certain something, no matter how subtle. Isolate those individual strengths, and focus on them when you're shooting your movie subjects, just as you would in the case of reluctant home-movie stars.

This doesn't mean you should melodramatically point the camera and say, "Listen, viewers, now we're going to hear a few words from Jeff, who is absolutely the funniest guy in the whole world. Okay . . . Jeff, say something hysterically funny—now!" Rather, keep a person's strong suits in the back of your mind, and don't miss an opportunity to do justice to those attributes when and if the occasion arises. In the end, you'll help your cast members look their best. And when they do, they'll think *you* are a genius.

Dick Martin, the frequent director of "Newhart" and other top-rated TV series, put it this way: "If you've got six people in your home movie, you've got six talents who can look like six stars or six bombs, depending upon how you capture them with your camera. Use your movie as a showcase for your family's natural abilities."

2

TAKING PART:
GETTING
EVERYONE INVOLVED

Most home videos are essentially one-person productions. Following the generations-old tradition of snapshot picture-taking, the kids go through their particular motions while one of the parents points the camera and pushes the appropriate buttons. "Smile!" *Click!* That's it.

Well, that's not it at all when it comes to video picture-taking. The act of home moviemaking really shares more with the communal, collaborative process of production-company moviemaking than it does with the personal, solitary task of the still photographer. A movie—any movie—is a blend of picture, sound, movement, nature, machinery and emotion, merged by the diversified abilities of people working together for a common purpose. That's why all the Hollywood execs always call the movies a "people business," in which said people just so happen to make said executives very rich. Take away the *business* when you're making movies for pure pleasure, and what's left? What could be more important than the *people* involved in your movies?

One-person moviemaking may be adequate for certain types of videotaping, such as recording your household possessions for insurance purposes. However, home moviemaking can become significantly more than the technical act of recording images for posterity. It has the potential to involve every member of the family in a virtually limitless variety of projects that can be fun, enlightening and memorable for everyone involved.

But everyone *has to* be involved in one way or another for the rewards of home moviemaking to approach their potential. When each of the members of a family makes a genuine contribution to a project, each one can garner an important sense of belonging and accomplishment from that project. Contrarily, when the kids perceive the video camera only as the object of father's infatuation or as part of the grown-ups' domain, a precious opportunity is lost.

Most kids usually want to be involved in the hands-on side of making home movies. After all, video belongs to *their* generation, not their parents'. High technology is a normal, natural part of daily life for today's children. Their parents may be part of the first TV generation, having been raised in the '50s and '60s. But a youngster's life among the VCRs, personal computers, and home satellite receivers of today is hard to compare with watching "The Howdy Doody Show" 30 years ago. Often, I've found, parents tend to separate their kids from the behind-the-camera aspect of high-tech projects in the name of safety and other parental scapegoats, when it's they who are actually afraid of the equipment.

Old enough to shoot: Should a child be allowed to use the camera? The answer depends on age, ability, and the equipment's warranty. The girl below is holding the camera properly.

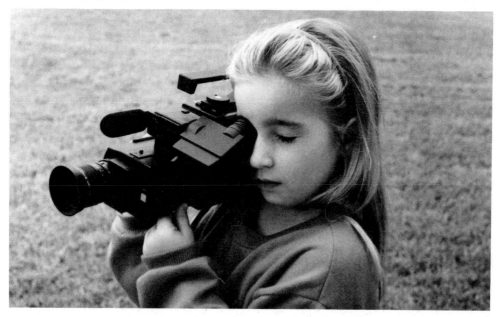

Consider your children's maturity and coordination in making decisions about whether to let the kids take the video camera into their own hands. Age is less pertinent than ability. For instance, I know of one four-year-old who apparently shoots wonderful videos of his stuffed animals, complete with clever lighting effects and action-packed narration he improvises on the spot. However, I suspect he may get some secret assistance from his dad, Sam Weisman, who happens to be the director of "Family Ties."

Unless someone in your house is the director of a prime-time network TV series, I wouldn't entrust a $1,000 piece of electronic componentry to a person who just recently learned how to hold a fork. The best guidelines I can offer on the subject come from my experience as a guest instructor in various elementary school systems. By fourth grade or the age of nine or ten, many children I've seen are responsible and adept enough to handle some simple, straightforward video camerawork. That is, assuming they're well supervised and your camera is covered by a comprehensive warranty.

The main point is to give everyone in your family *some* off-camera responsibility, even if the parents retain their prerogative to handle the camerawork. Moreover, each person should be assigned a specific, clearly delineated job, with meaningful responsibilities in that area for the duration of the movie project. For example, various kids can be put in charge of the lights, the make-up, the sound, and so forth.

None of these jobs should require so much work that the kids feel taxed or intimidated. This isn't a major issue, though. No one is likely to find himself with an excessive workload unless you're combining outer-space effects, authentic Elizabethan costumes, and circus animals in one big (and very weird) movie. Conversely, none of the assigned jobs should be mere empty titles. If you designate your daughter the make-up person, and then say, "We don't have any time for make-up, so go somewhere and play," you're asking for a powder puff in the face.

Here's a rundown of the ten basic home-movie production jobs. They're important to understand, even if you prefer to do everything yourself, stubbornly and selfishly. (By the way, I know the following job titles are formal and overblown—just the way people love them.)

Producer and Director

In a family movie crew, the parents are the producers, in every sense of the word. As such, they have *final* authority over every matter related to making

the movie. Yet good producers are much like good parents—they provide the underlying support, the environment, the time and the money necessary, then they keep their distance unless they're needed.

The director is the chief active decision-maker on the home-movie "set," and he or she does not necessarily need to be one of the parents. Once the parents have established the basic rules and standards, and especially after the first family movie or two, any child old enough to handle the director's role may be given a chance to try it.

What is that role? In chronological sequence, the director is responsible for all of the following:

- Deciding on the movie idea, story line or script, if there is one
- Assigning roles to the cast
- Coaching the performers
- Directing the camera operator (or working the camera himself or herself)
- Approving (preferably more often than rejecting) the decisions of all the other members of the crew
- Editing (if appropriate and if no one is designated as editor).

Despite the power implied by all of the above, home-movie directors must understand and accept that their role is essentially *secondary*. They're supposed to direct—to steer, to guide the others—not to originate and execute every idea in the movie.

"The one thing every director should know," Jay Sandrich, the director of "The Cosby Show," told me, "is that the director doesn't have to know everything. Listen to all the other people you're making your movie with, whenever they have something to say. Trust them and trust your own judgment, and you'll make a great home movie and have one heck of a good time doing it."

Story Editor

Every movie tells—or *should* tell—a story, whether that story is a structured fictional tale or a live event taking unpredictable turns. The duty of the story editor is to make sure the content of the movie is conveyed accurately, coherently and economically. Before shooting, the story editor might write a full-scale script or, at the very least, a working outline of the sequence of events about to unfold in the movie. During the shoot, he or she should

monitor all the action to make sure the movie stays on course in terms of continuity and sense. (See page 19, "What to Shoot.")

Camera Operator

Part visual artist, part technician, the camera operator is responsible for proper use and care of the video camera or camcorder. He or she needs both a good eye for composition and a half-decent understanding of video equipment. Unless the director specifies otherwise, the camera operator decides what camera angles, cropping and other photographic particulars to use in every shot. (See page 23, "How to Shoot It.")

Technical Advisor

Here's the perfect job for the neighborhood "techie," although you don't need the president of the Science Club to work with today's video equipment. Most of it is so simple that even an adult can use it. The technical advisor's main responsibilities are the following: to see that batteries are always charged up and ready to use; to handle extension cords and other electrical cables and wires; and to carry, use and maintain all other accessories, such as tripods, lenses, filters, etc. (with the exception of lighting and sound equipment; see *Lighting Director* and *Sound Chief*, below). A technically proficient parent should always make a point to double-check this crew member's hook-ups for accuracy and safety.

Set Supervisor

So you don't use custom-built sets when you make home movies? That doesn't stop the set supervisor from having a very valuable and difficult job. Say you'd like to shoot somewhere that looks like the jungles of deepest Africa. It's the set supervisor's responsibility to scout out locations in your area till he or she finds something right (or close enough). When you want to shoot a scene by the downtown hotdog stand, the set supervisor is the one who has to get the vendor's permission. Even when you're taping in your own house, there always seem to be things such as wall hangings, furniture and

other household objects that need to be moved out of or into certain rooms to accommodate particular shots in your movie.

Lighting Director

Because most of today's video cameras are highly sensitive to light, they rarely call for the use of special lights like old super-8 film cameras always required. The lighting director's job is to see that the natural, ambient light in every scene is *right*—that is, it has the right tone, is directed at the right people, and is free of distracting glare and other problems. When necessary, additional lights and lighting accessories, such as shades and umbrellas, are the responsibility of the lighting director. (See page 71, "Indoors.")

Sound Chief

Like the lighting director, the sound chief needs to foresee and solve problems that the video camera's built-in technology can't accommodate. This may involve any of the following particulars: eliminating unwanted room noises emanating from clocks or flourescent light fixtures; coaching certain performers to speak more quietly or loudly; producing sound effects with props or tapes; and hooking up accessory microphones such as wireless or boom mikes. (See page 119, "Lenses, Lights, and Microphones.")

Make-Up Artist

The most-wanted job among young girls in the family is that of the make-up artist, who helps performers look their best through the strategic application of conventional cosmetics and hair products. Faces, hands, and hair all require the make-up artist's skills, hopefully in subtle doses.

Costume and Wardrobe Manager

The perfect job for the girl who didn't get to be make-up artist. The costume and wardrobe manager is responsible for refining the look of performers in your tapes. Most of the time, the pertinent responsibilities involve critiquing

the cast's outfits (watch out!); finding or creating special outfits or accent pieces for particular projects; and, occasionally, creating complete period costumes.

Gofer ("Go-For")

Called the production assistant (P.A.) on professional shoots, this is the quick-thinking, fast-acting troubleshooter who has to get everything done that doesn't fall into anyone else's realm of responsibilities. He or she's the one called upon to "go for" props, snacks, and heaven-knows-what-else you may suddenly need. It's an important job, but not always one perceived as such, so try to have kids take turns at it.

3

WHAT TO SHOOT:
YOUR MOVIE'S SUBJECT MATTER

We do something that's normal yet strange when we first start to make home-video movies of our families. We base their contents on our instincts about what home movies *should* be, which, naturally, are derived from all the super-8 films we've seen over the years. Since those old home movies of birthdays, weddings and backyard barbeques form our primary frame of reference, we find ourselves mimicking them, consciously or not. In other words, we essentially make *home movies of home movies*. We don't really make home movies of *our lives*.

In the super-8 days, parents concentrated on filming family rites of passage and other major events for reasons inapplicable to the video age. They shot very special occasions because home movies were a very special thing. Considering the costs of the equipment, film and processing, plus the demands of utilizing cameras, projectors, screens (and sometimes synchronized tape recorders), super-8 moviemaking was a highly expensive and complicated endeavor. Moreover, our parents' primary photographic frame of reference was their own parents' snapshots of birthdays, weddings, and backyard barbeques—because, two generations ago, *still* photography was a highly expensive and complicated endeavor.

Today, home video is making moviemaking a snap. We can shoot eight

hours of movies on a five-dollar tape, with no processing involved, then play the recordings back on the TV set. With many of the recent aim-and-shoot video cameras, we can tape almost anything and everything we see. Now the challenge of the video generation is to break out of our old habits and, at the same time, make the most of video's unprecedented potential. We need to learn to shoot much more than birthdays and barbecues, but we needn't shoot anything and everything we see, either.

What should you shoot? The better question is: What would you be doing if you *weren't* shooting? Whatever it might be, that's what you should vid-eotape—the everyday activities at which your family spends the majority of time. Those are the things that will someday make up your most heartfelt memories. So they should be the subject of the home movies you're creating now to reaffirm, preserve, and share those memories for generations to come.

To merit making a home movie, your subject matter doesn't have to be as newsworthy as a Geneva summit conference. As a matter of fact, almost anything you'd shoot would probably be *more* interesting than that, if not as funny. You can create a worthwhile movie about any slice-of-your-life story, such as washing the car, going to the doctor, baking cookies, exploring the woods or a visit from grandma and grandpa.

Furthermore, the content of your movies certainly doesn't have to be restricted to *events*. Terrific movies can be built around particular *ideas* or *themes*, such as memories, wishes, problems, pet peeves, and so forth. As an example, I've been making one tape with my son Jake ever since he was four. Called *My Favorite Stuff*, it's a compilation of brief scenes, one of which I shoot every three to five months, wherein he talks about what he happens to be excited about at that point. At first, he simply blurted single phrases such as "I like ice cream!" then ran out of frame. Lately, though, he's taken to performing short show-and-tell demonstrations of his favorite toys and games. I hope to keep adding to the tape for at least a few more years, perhaps stretching the intervals between shoots to a year or so. Obviously, the idea can be adapted to a variety of themes for boys or girls, from *My Favorite Dolls* to *My Latest Heart-Throb*.

The whole topic of content or "story" boils down to one essential rule: Tape whatever best represents your family's life, whatever reveals your family's character. Tape what comes naturally. *Tape what you love.* Above all else, this simple guideline is the secret of creating memorable video stories.

According to *The Wall Street Journal*, the average American family's favorite pastime is (after watching TV) browsing through shopping malls. Meanwhile, the *Journal* said, the average parents spend only 40 minutes per week

playing with their children. Okay—if these facts sound about right to you, make a movie about the family browsing through the mall (assuming you can finish it in 40 minutes). I'm completely serious.

The idea might sound stupid, but I bet that if you watch that particular movie ten years from now, you'll say, "Look—*that's us to a 'T'!*" A tape about shopping might sound excruciatingly dull, but I bet that you can make a genuinely interesting home movie based on any idea that has real relevance to your life, if you plan your story well.

One of the most elemental aspects of good story planning is *structure*. Every movie needs to have a shape—a direction, a design—both to guide you and your family in the shooting process and to guide your viewers as they're watching the finished tape. Try to resist the compelling temptation to wing it and see what happens once you start. Without so much as a simple mental outline of what you want to shoot, your movie can rapidly turn into an unmanagable and virtually unviewable mess.

The clearest and simplest structure to use with most projects is, unquestionably, chronological linearity. That is, follow the sequence of events involved in your story from beginning to end. The main problem with this approach is that it's far easier said than done. Once you start to tape, all sorts of surprises inevitably crop up to tempt you into taping too much, too little, or no footage whatsoever, of the people or incidents pertinent to your story. I once found myself shooting an entire stick-ball game in my son's school gym, despite the fact that I went there to tape him in the Christmas play that followed. He finished the game in time to make his cue but by then I had run out of tape.

To avoid losing control of your projects, make the early effort to outline the five to ten main things you want to tape, in sequence. Then, follow the outline!

All your movies needn't—indeed, shouldn't—be structured chronologically. In many instances, your subject matter may not even suggest chronology. You might be taping an exhibition of your daughter's doll collection; a show of your son's trick basketball shots; a tour through the kids' favorite "adventure places." When you're making movies like these, you'll probably want to organize the various elements in ways such as oldest-to-newest, easiest-to-hardest, nearest-to-farthest, or *vice versa* for any of the above.

Additionally, you ought to try to create and sustain some *momentum* through the structure of your movie. Every audience wants to be pulled emotionally along and taken to somewhere worthwhile in the end. Don't go off on tangents. And save the best till last.

Whatever movie you might be making, try to decide upon a structure that's a natural fit for that movie and for the orientation of your family and yourself. In the words of French director Jean-Luc Godard, "I think a movie should have a beginning, a middle and an end. But not necessarily in that order."

Don't get too arty in your story plan, however. *Clarity* is critical to communicating your story. It's difficult to keep your mind on how the movie will "read" upon completion, whenever you're very close to your subject—and who could be closer to their subjects than parents shooting their kids? Once you replay a tape a year or so after you made it, you may well wonder what in the world was going on in some of the scenes.

Try to think objectively about all the aspects of your story when you're constructing it. For instance, if your movie is about your daughter painting, don't give dad the room to filibuster about his own childhood artistic prowess. The point of this particular project is supposed to be your daughter's work, specifically. Another day, dad can pontificate about himself in a separate video-history tape.

This area overlaps another key subject: *economy.* Keep your story outline lean. Cut out every bit of business that's unessential to the telling of the tale, no matter how cute or clever the ideas may seem at the time. It's painful to do, because we're all so proud of creating such brilliant ideas all by our vain little selves.

Speaking of egos, make certain to *know your subject* when you're planning you home-movie story. Gifted with unbounded imaginations, your kids are surely going to suggest making movies about scientists or sailors or the circus or only heaven-knows-what-else. By all means, do it, but only if and when you're fully confident about mixing strange chemicals, heading out into the lake, or hanging from a home-made trapeze.

4

HOW TO SHOOT IT:
THE CRAFT
OF MOVIEMAKING

Great tales are all in the telling. From Scheherezade to the guy in the office with the hysterical jokes, some people have that irresistible way with words. It's a matter of choosing the right turn of phrase, of lingering on a single syllable, of accenting sentences with a gesture or a glance. We all understand how it works, even if we can't do it ourselves.

What fewer people understand is that the same basic rules apply to telling *visual* tales. There's such a thing as having a way with *images*. When you're telling stories on home video, it's a matter of choosing the right picture, of lingering on a single shot, of accenting scenes with a pan or a zoom of the lens. (Keep reading if you're unfamiliar with these terms.) You simply have to learn how it works, and it isn't terribly mysterious at all.

Instead of sentences, you're communicating with *shots*—individual units of visual and aural information. Every time you turn the camera on and off, you're starting and ending another shot, another unit of information. Through your choice and execution of shots, you tell your story on video. Everything you want to communicate has to be there. Viewers can see only what you show, hear only what you voice, understand only what you explain, and infer only what you imply in the specific shots you choose.

With every shot, make sure you understand not only what you're showing,

but also what you're *conveying* through the images and sounds in that shot. Each one of your shots should have a point, a clear rationale for inclusion in your movie. And remember that fact before you start to roll tape; otherwise, you'll have to go back and erase or edit, which most people don't feel like doing once they have some footage on tape.

Let me walk you through the process of choosing shots with their messages in mind. Say you're going to tape your kids building a backyard clubhouse with their neighborhood friends. What shot should come first? How about starting at the very beginning of the day, by shooting each of your kids getting out of bed?

Well, okay—if (and *only* if) a shot of one of the kids in bed says something relevant to the story at hand. Perhaps, one of the kids was so excited in anticipation of the upcoming day's project that he or she got up two hours earlier than usual. Or perhaps one of the kids overslept, and missed the early stages of building the clubhouse. Or, perhaps you first announced the project to the kids in bed. All of these possibilities would make for strong, relevant scenes to open your movie. Otherwise, hold off on that shot of the kids awakening until it's Christmas morning.

What other shots might you include in or exclude from your clubhouse movie? What about mom or dad making lunch for the kids? Sure—it's pertinent to the story, particularly if the parent comments on the kids' project; but keep it short. What about baby sister playing alone inside, because she's too small to build with the older kids? Definitely—how the youngest member of the house adapts to the family goings-on is very important; also, it could make for a sweet sub-plot (also called the "B" story). What about the kids celebrating the completion of the project with sodas and snacks? Naturally— and that's a good finale. Just don't get carried away with your taping and continue shooting the kids as they put down their drinks and start up a game of Frisbee. Do shoot a whole new Frisbee movie, if you'd like, but address it as a separate and unique project.

In my NYU film-school days, the head of the Film Production Department, the late Haig Manoogian, drilled us on the idea of shots as "emotional units," and I've never forgotten it. The idea is invaluable whether you're shooting big-budget productions or home movies, as you can see in the meticulously shot work of Manoogian's protegé, Martin Scorsese. The Academy Award-winning director frequently shoots short, intimate films about his family and friends, some of which (such as *Italianamerican* and *American Boy*) occasionally appear on cable and public TV. Watch for them; they're textbook examples of impeccable shot selection in the context of small-scale family

moviemaking. Throughout *Italianamerican* (a profile of Scorsese's parents), each scene is made to vividly depict a facet of the elder Scorseses' personalities; virtually every sequence is an "emotional unit."

Composition and Style

Once you've decided on the content of a given shot, the next issue is *how* to shoot it. Style comes into play. How should you frame, or "compose," your shots? Should you shoot a close-up? A pan? A zoom? Or something fancier?

Conversation pieces: The composition of your shots and their sequence should guide viewers to a clear understanding of what's happening. Here, shot #1 establishes the overall scene of Megan and her mother chatting. Shots #2 and #3 (called "over-the-shoulder" shots) bring the viewers closer to the subjects, followed by shots #4 and #5 (close-ups).

In professional movies, this approach—using an establishing shot, followed by over-the-shoulder shots, then close-ups—is a standard way of shooting conversations, because it effectively employs composition and sequence to build momentum within a scene.

2

3

4

5

It all depends, again, on what you want to communicate. The style of your movie should emerge organically out of your content and your goals. If you don't have a special idea in mind, you should simply try to cover the action. Compose clean, straightforward shots, each of whose focal point is the specific person, object or activity key to that shot. Beyond that main objective, here are some broadly applicable guidelines for effective composition of home-movie shots:

• The most important part of a shot should usually appear in the left half of the picture frame; owing to a peculiarity of perception, most viewers seem to be more strongly attracted to that side.
• Avoid symmetry when composing most shots. When both halves of the frame are balanced, a shot takes on a static, uninviting quality. When you're shooting two people standing next to each other, for instance, move slightly to one side of one of them, in order to put one person slightly in the foreground and the other a touch in the background. The result will be an element of depth and improved visual appeal.
• Static subjects should be shot so there's more space on the side of the frame into which they're facing. Similarly, moving subjects should be shot so there's more space on the side of the frame into which they're moving. Both rules are meant to help you draw attention to, not from, the subjects' particular activity.
• The bottom of a frame should never intersect a subject's joints (shoulders, elbows, hips, knees, ankles). Rather, it should fall between joints. I'm not sure why, to tell you the truth; but professionals swear by the rule, and it does seem to make people look more natural somehow.

Once a shot is composed and executed, your next responsibility is to make sure your movie makes sense as it moves from shot to shot. You need to maintain *continuity*—consistency in content and action among sequential shots. For continuity in content, simply make sure all the same people and objects are in the right places, whenever you're changing shots within a certain scene. It isn't hard, if you remember to think about it. As for continuity in action, you have to learn and never break the professional camera operators' "180-degree rule."

That is, *never cross the imaginary line.* In accordance with the 180-degree rule, you must always immediately draw an imaginary line (called the "axis")

between your subjects and yourself, no matter where you decide to stand when you start shooting your movie. From that point on, you're free to move the camera wherever you please, as long as you never cross that imaginary line. The reason: In doing so, you disorient the viewer—disrupt his or her visual equilibrium. That's why televised football games and other sports events are invariably shot from only *one* side of the field. If they weren't, you'd never be sure which way which players were running when.

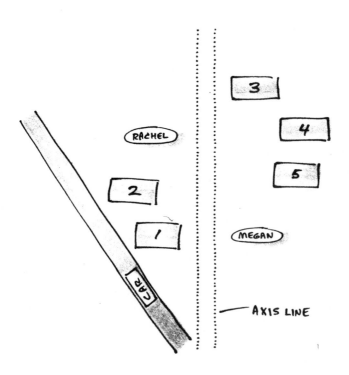

Continuity by degrees: The diagram above represents an aerial view of Megan (the blonde) and Rachel (the brunette) playing catch in the following series. In accordance with the "180-degree rule," there's an axis line (depicted in the diagram by parallel dotted lines) between the girls. Remember, the line could go *anywhere* in the scene. But in order to avoid confusing the viewer, you should shoot from only one side of the line, never crossing it within the same story sequence. As examples, you could use either shots #1 and #2 *or* shots #3, #4, and #5, but not a combination of both.

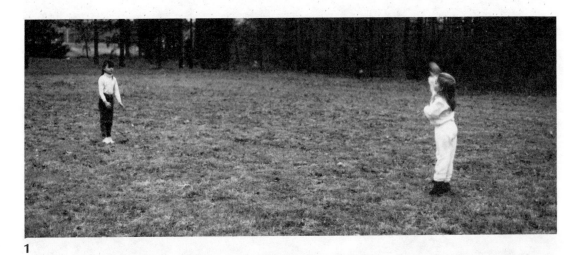

1

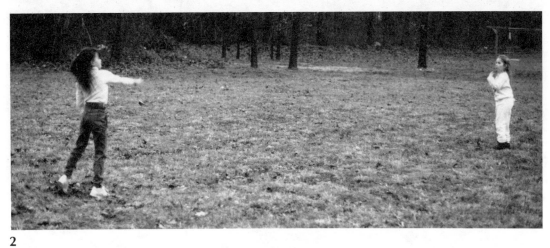

2

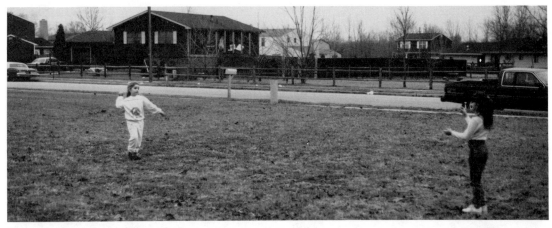

3

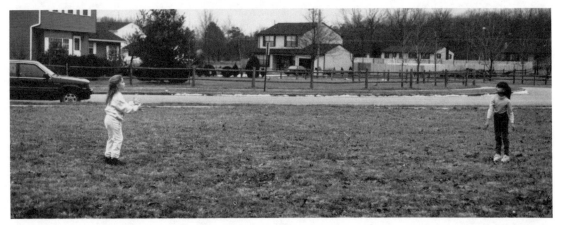

4

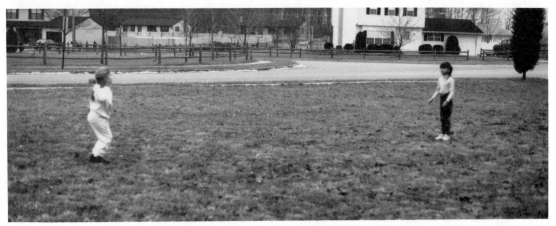

5

As an extension of the same rule, it's critical to always keep moving objects moving in the same direction from shot to shot. When the kids line up for a big game of "Pin the Tail on the Donkey," make sure you shoot them all from the same side, unless one of them turns *you* around by trying to pin the tail on the camera.

Now for the fancy stuff. When is the best time to zoom, pan, fade, and try out all the other neat, irresistible, and expensive buttons on your camera? All in time, itchy-fingers. But before you attempt literally anything other than simple shots to cover the action, you should understand exactly what you would be *saying* by doing so. After all, the various videotaping techniques at your disposal aren't just arbitrary tricks. Each has a distinctive way of accenting a shot and affecting the viewer's perception of its content. Together they make up the grammar of the language of moviemaking.

Here's a capsule lesson in the elements of home moviemaking style:

Long Shot

Covers a significant amount of territory from a distance. Often serves as an "establishing" shot at the beginning of a movie or scene, to root the audience in a place and time. A long shot can also have a pacifying effect on viewers, unless it's covering a great deal of action, such as a shot of a Little League game or a busy playground.

Medium Shot

Full-body coverage. Ideal for most family home-movie purposes, this is the "vanilla" shot—the one that imposes minimal meaning of its own.

Close-up

Head shots or closer. Best used strictly for dramatic emphasis, a close-up intensifies the viewers' attention and increases their expectations. It also puts strong demands on the performing ability (not to mention the looks) of family members if they're playing dramatic roles in a home movie.

Pan

Horizontal, hand-pivoted camera movement. Employed to convey scope and sweep in establishing shots and in landscape shots. Alternatively, used as a transitional device to change focal points within a shot. A pan is a set-up; use it only when you can live up to its promise with a pay-off (some change of scene or focal point worth changing to).

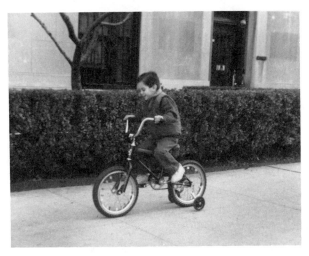

1

2

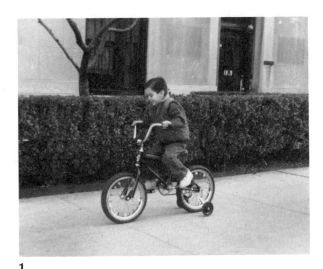

1

2

Moving experience: It's critical to maintain continuity of motion from shot to shot. Here, Jake (in the down vest) and Andrew (in the sweater) are riding bikes together. But is Andrew following Jake, or is he heading straight toward him? The answer— or the *video illusion*—depends on which side of the boys you stand on during each shot.

In the sequence on top, Jake and Andrew appear to be riding in the same direction, in a chase scene, perhaps. But in the next sequence, by simply changing camera position, the boys seem to be heading toward each other, ready to crash.

3

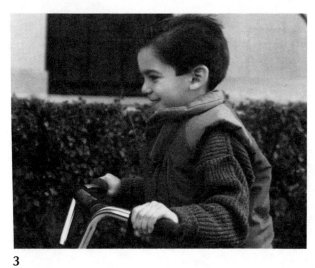

3

Good zooming: Here's one creative way to use the zoom lens. The camera never moves as Megan skooters closer and closer. By zooming *in* as she moves forward, she stays about the same size in the frame, while the background appears to recede.

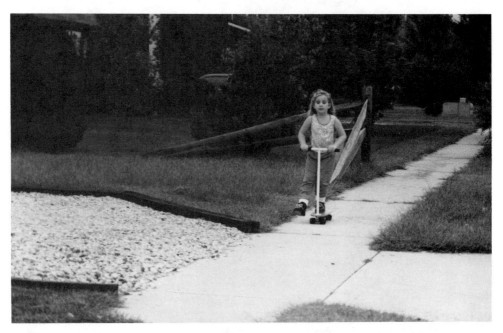

1

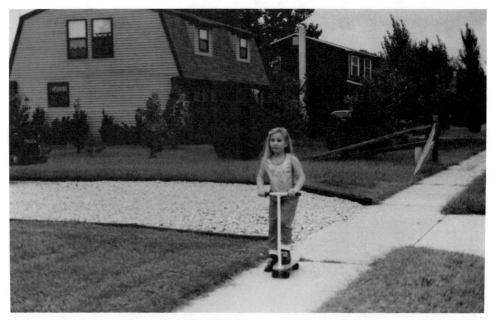

2

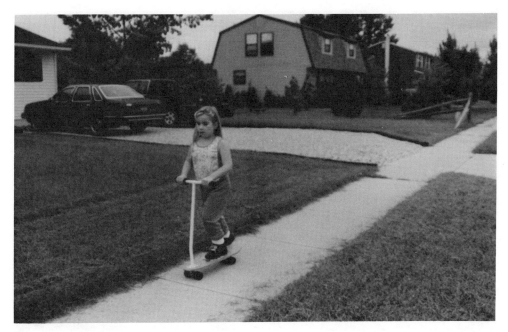

3

Zoom

Gradual closing in or easing back from a given perspective. Another set-up shot, this one is essentially a combination pan and close-up (at least when you're zooming *in*). A highly powerful effect best reserved for rare melodramatic and shock purposes.

May be used without melodramatic effect in certain circumstances, in order to follow the action when subjects are moving toward or away from the camera.

Similar to a zoom, a *dolly shot* brings subjects closer or further by movement of the camera, as opposed to a change in lens setting. For instance, shots taken while walking or moving in a car are basically dolly shots. For authentic dolly shots, however, you need a dolly—a wheeled gadget (such as a sturdy wagon or, believe it or not, a strong baby stroller) to sit in or stand on while you're shooting.

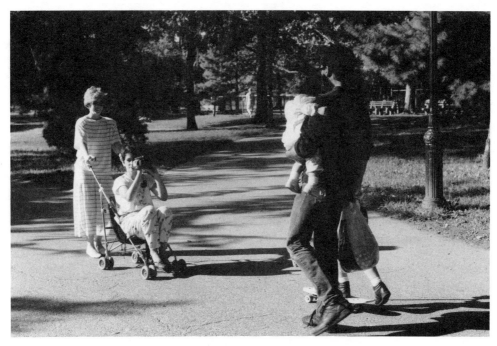

Don't walk, dolly: Instead of trying to walk while you're shooting, in order to follow moving subjects, use a *dolly shot*. All it takes is a stroller—a very sturdy one, of course—and somebody trim enough to do the camerawork.

Cut

An ordinary change of shots, as opposed to a fade or other transitional technique. Also called a "straight cut," it indicates a change in focal point within an established scene, usually without breaking continuity, time or place.

Fade

Gradual emergence or dissipation of an image, from or to complete black. Should be used only to mark a distinct departure from the established time and place. Never fade out and in within one scene; your viewers are likely to think your characters all went to have dinner or something, then came back. If you fade after a long kiss, your viewers may be prone to certain other assumptions.

5

THE VIDEO CAMERA:
WHAT IT
CAN—AND CANNOT—DO

For parents accustomed to still-photo cameras, looking into home video is a lot like looking through a variety of photographic lenses. In one view, the multitude of unknown brands and models makes video seem further from a snapshot photographer's frame of reference than it actually is. In another view, certain familiar features make video cameras and camcorders seem closer to 35-mm cameras than they really are. And in some ways, the whole world of video equipment appears as weird as the view through an extreme fisheye lens.

What's reality and what's distortion when it comes to video moviemaking products? To start with, there is indeed an extremely large and rapidly changing selection of video cameras and camcorders—more than 100 models in four major formats, sold under more than 30 brand names at any given time, with new products introduced every few months. Suggested retail prices range from around $700 or $2,000, depending upon the availability and sophistication of about two dozen features from such basics as zoom lenses to such advanced capabilities as digital automatic focus.

Camcorders vs. Cameras

I've used the term "camera" to refer to both cameras and camcorders throughout this book, as most people do most of the time. In this technically oriented chapter, however, the terms will be mutually exclusive.

Stripped to their essence, most camcorders share some basic characteristics, as do most 35-mm cameras. Whatever the particular make or model, every camcorder is a one-piece combination camera and video-cassette recorder. The camera portion captures light with a conventional lens, processes images electronically through a pick-up device (either a tube or a solid-state sensor), and feeds the image information to an internal VCR for recording and playback through either the camcorder's own viewfinder or a conventional TV set. Simultaneously, sound is received by a built-in microphone for recording and playback through the audio circuitry of the internal VCR.

Unlike a camcorder, a video camera functions in concert with a separate VCR, whether a battery-powered portable or a home recorder. Together, the camera and the recorder work as advanced audio-video progeny of a hand mike connected to an audio tape recorder. That is, the camera receives sensory input (both aural and visual) from the natural world and translates it into electronic information. Then, the portable VCR records that information on cassettes for playback.

Since the mid-'80s, camcorders have virtually replaced cameras as the prevailing video moviemaking technology, owing to their relative ease of use and stylish design. Originally patterned after professional electronic-newsgathering cameras, camcorders have recently evolved to a stage more suggestive of traditional 8-mm film movie cameras. Simple, small, and as unassuming as the grandparents' old movie outfit, many of the newest camcorders are highly attractive and ergonomic hybrids of internal electronic intricacy and appealing design. A typical model might weigh three to five pounds (excluding battery), with dimensions of about 4" x 5" x 10" (height by width by depth).

Performance quality can vary from model to model, depending mostly upon the feature package and the recording technique (or format—Beta, 8-mm, SuperBeta, Super-VHS, VHS, VHS-C; see below). As with every type of camera, a camcorder should be selected carefully, on the basis of individual applications, taste, budget, and other personal concerns. To help guide camcorder shoppers in assessing the relative merits and liabilities of the latest models, here are thumbnail descriptions of the four major camcorder formats. (Virtually discontinued, Beta and SuperBeta camcorders have come to represent a minimal proportion of camcorder ownership, despite the superb quality of the equipment.)

8-mm

The most popular camcorder format among the forward-thinking video fans of Japan and West Germany, 8-mm is promoted as the configuration of the future by its American devotees. The format is advantageous not only for its miniature cassette, about the same size as a standard audio cassette, but also for its variety of applications. In addition to camcorder use, the 8-mm format makes possible a range of unusual "personal video" products such as portable VCR-TV sets plus home 8-mm VCR decks for taping from TV or playing prerecorded 8-mm cassettes, as well as digital audio recording. In fact, 8-mm recorders are available for recording up to *24 hours* of fully digital sound on a single cassette, approaching (though not quite matching) the audio fidelity of compact discs.

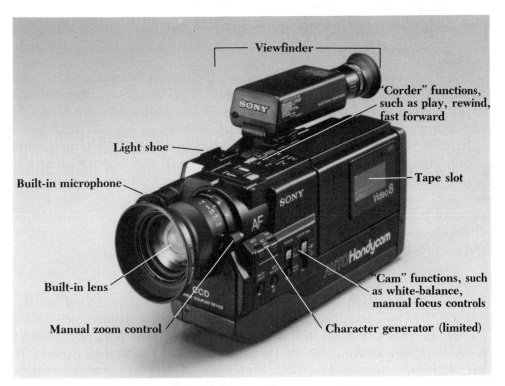

What's what on a typical camcorder: Sony's 8-mm model.

Super-VHS

The best-performing camcorder in a popular home configuration, Super-VHS (also called S-VHS) is the format for many connoisseurs of electronic image reproduction. Indeed, the performance of these complexly engineered camcorders exceeds the quality of *broadcast TV* images reproduced on the vast majority of American TV sets and monitors. According to the JVC company—the developer of the format—S-VHS produces horizontal resolution in excess of 400 lines (compared with the 240 lines typical of standard broadcast reception), in addition to significant refinements in signal-to-noise ratio and color. The resulting improvement over the quality of conventional VHS can be compared with the audible difference between the sounds of vinyl LPs and compact discs.

Meanwhile, VHS's old rivals, the Beta manufacturers, have introduced a still more superior format, ED (Extended Definition) Beta. However, the ED Beta equipment is available in extremely limited quantities, mostly through "exclusive" video boutiques or special orders.

VHS

The most familiar camcorder format, VHS employs the standard, full-size cassettes that more than 80 percent of today's VCR owners are already using for TV recording and movie rentals. Largely for that reason, VHS was the best-selling camcorder format until the late '80s when full-size VHS began to be inched out by the newer, smaller 8-mm and VHS-C. The mere bulk of the VHS cassette requires commensurate bulk in VHS camcorders—a feature that may be a boon or a drawback, depending upon the user's orientation. Some home moviemakers prefer full-size VHS camcorders for the shooting stability of their shoulder-rest configuration, as well as for the additional features on some VHS models. Others opt for the much more compact and frequently simpler 8-mm and VHS-C.

VHS-C

The spin-off mini-format of the VHS family combines two chief assets of full-size VHS and 8-mm: compactness and compatibility, respectively. About the size of a pack of cigarettes, a VHS-C cassette is less than one-third the dimensions of a conventional VHS tape (still a tad larger than 8-mm). Yet VHS-C is fully compatible with its big-cousin VHS by use of an adapter the size of a standard VHS cassette, into which the VHS-C tape can be inserted. Moreover, the advanced Super-VHS technology, with radically improved image quality, has been incorporated into VHS-C camcorders in several *S-VHS-C* models.

6

BEFORE YOU SHOOT:
A CHECKLIST

In the timeless parental tradition of ruining a kid's fun with a long, dispiriting litany of negatives, here's my list of ten basic "don'ts" for *parents* to remember before making home video movies. As my mother used to say, *Never dare to so much as think about doing those things. Now go and have a good time.*

Don't expect too much. You're only making a home movie, not *Apocalypse Now*. The finished project will certainly be riddled with things you could have done better or shouldn't have done at all, but you may end up enjoying them the most.

Don't underprepare. The whole family will be at its best performing—and at its best behavior—when you know precisely what *you're* doing and what to expect from *them*. Uncertainty can breed chaos.

Don't overprepare. You can work yourself into a trap by compulsively contriving every camera angle and every action of every person in your movie. Try to find a middle ground between faking and fossilizing the plan of your movie.

Don't try to know it all. You don't and shouldn't, so don't pretend you do or should. The pros have told me over and over: The best directors are the best listeners. And the point is infinitely more important when your own kids are involved.

Don't try to do it all. Why entice the kids with the prospect of sharing in an exciting family activity, only to hog all the fun yourself? That won't teach them anything except resentment.

Don't be stubborn. Never fear for how you might look to your kids if you change your mind. Displaying obstinacy is a worse example to set than fickleness, and it won't help your movie, either. Do what's really best, even if you've gotten yourself neck-deep in a commitment to the opposite.

Don't overrate technology. You'll be surprised at what your equipment can do—probably quite a bit less than you think. Make the effort to understand all your video products' capabilities as well as their limitations.

Don't push people around. Directing a movie can go to your head, so get that beret off and do your job. That is, be a *parent*.

Don't overdirect. Too many "takes," camera angles and technical demands can drain the life out of a film and a family. Keep it simple, with essential exceptions only.

Don't get too serious. It's one thing to take on a project with earnestness and responsibility; it's another thing to be morbid about it. Can a home movie mean so much to you that you'll preclude its *fun* from your kids?

II

THE FOUR "S's"

7

SPECIAL OCCASIONS:
HOME VIDEO
AND THE HOLIDAYS

Pregnancy

Let's start at the beginning—or *before* the beginning. Prior to a child's birth, the pregnancy itself can be one of the most dramatic subjects you could videotape. Few phenomena in the course of our lives rival the thrill, the suspense and the mystery of a human life taking form. No wonder so many video camera sales are associated with pending births.

Unfortunately, since pending parenthood is often one of the first subjects a new camera owner takes on, the topic is rarely addressed with a great deal of forethought or surety. In the typical movie, the mother-to-be is shown doing miscellaneous things at random stages in her term, looking uncomfortable. And the discomfort seems due less to her baby than to her mate, waving that video camera at her.

In home movies, just as in life, pregnancy needs to be handled delicately. Both of the expecting parents should sit down, discuss and agree upon how to treat the topic, before rolling tape. Without exception, the mother should be a full creative participant in the movie, not a mere object under scrutiny. She must never be made to feel like an exhibit or, worse yet, an oddity. This may sound strange to many fathers enthralled by the dramatic changes in their wives, but some women feel out-of-place, even unattractive, when they're pregnant. The camera can amplify these feelings.

Fathers: don't dismiss or make light of this issue; rather, always ask the mother if she's in the mood to be videotaped, what she'd like to wear, and what specifically about her condition she'd feel comfortable discussing on-camera. Mothers: don't forget to shoot the father, too. There's certainly more to pending parenthood than pregnancy, such as paternity and "nesting," and they all ought to be included in your movie.

Births

When the delivery day finally comes, you might be interested in shooting the actual birth. Most parents-to-be with video cameras probably discuss the subject, although very few go through with it. At this point, videotaping childbirth generally seems to be perceived as a highly irregular practice of suspect motivation. It's like naming your child after your old, rich Uncle Seymour—something that may well pay off at some point in the future, but no big help to the child in the meantime, and most people will think you're a little weird for doing it.

To dispel one concern, let me assure you that there is absolutely no medical risk involved in taping the birth of a child. Video cameras don't require lights, and none of them emits any radiation or other mysterious electronic detriment to human life of any age. If the hospital grants the father (and the father only) permission to videotape—and that is frequently an enormous "if"—the attendants still won't let him and his camera within *reach* of the mother. And if he tries one camera angle or utters one syllable of narration deemed dangerously disruptive, he may well be thrown out of the delivery room before he can turn the camera off.

Mothers, you have to decide personally: do you want father to spend his time videotaping during the birth of your child? And is he capable of holding up (not to mention holding the camera still) during the procedure? If the answers are "yes," handle the project with extreme care, especially if you ever expect to play your tape for family or friends. In short, be sensitive to others' sensitivity about viewing the actual birth. Shoot it, but also shoot other footage to fill out the event, such as the mother's expressions (preferably *between* contractions), the doctor and nurses in attendance, the fetal monitor and other equipment, and of course the father/coach. Cover the action with tight head shots as well as more detailed (and more graphic) full-body shots. That way, you'll have the ability to edit two versions of the tape, one more explicit for private screening among members of the immediate family, and one more tame for general consumption.

Also, be forewarned that you'll get plenty of sarcastic snickers from disapproving friends. But I envy you, frankly, and so will some of those snickering friends, some day. Years after my own kids were born, I now wish I'd had the guts to have tried taping their first moment in the world. I know many other couples who feel the same way.

Birthdays

Like every other movie you make, a birthday tape should be addressed as a *story* from the planning stage through your final shot. Make sure to give the movie structure, sense and momentum by outlining the specific birthday events you want to include, in sequence. Then, as always, adhere to that outline. I raise—I stress—the issue once again, because birthday movies have an uncanny ability to rumble on and on, seemingly until it's time for the next birthday.

You'll naturally want to catch the formal highlights of a birthday. Blowing out the candles, opening the gifts and playing games—all are essential ingredients of the birthday-movie formula. But merely following the formula will give you a formula movie. For a vivid, evocative movie about *this* child on *this* birthday *this* year, you absolutely must stretch beyond the clichés into scenes that show what's unique about this particular child and this particular time of the child's life. You have to *personalize* the birthday, especially because it follows conventions common to every other birthday of every other kid.

For example, you could start your movie the day before the child's birthday, with a scene of him or her talking about last year's birthday and what the child loved the best about it. This would not only reveal something about the kid's character, but would also create some suspense about what will occur at this year's event. Additionally, you could tape the kid's best friends ahead of time, discussing the gifts they got your child. This would serve to tell us something enlightening about your kid, as well as to flesh out those friends as interesting people, not just so many faces in a room full of bodies going through the usual motions.

Major Holidays and Rites of Passage

Ditto everything above, whether you're taping Christmas, Channukah, Thanksgiving, other holidays or ceremonies such as a baptism, a first holy

communion, or a bar mitzvah. As you would with a birthday, capture and convey the true meaning that each of these occasions has for your family by *personalizing* the individual events. Millions of families celebrate Christmas every year. Why is yours worth videotaping at this point? Is this the first year your toddler is old enough to appreciate Santa? Did the pre-schooler save up his allowance to buy his first gift out of his own money? Is big sister coming home from college? Has grandma just recovered from a setback? Think about the particulars pertinent to your family at this point, and show them or talk about them on camera.

You might want to designate one cassette for a given holiday, and pop it in the camera to add some more footage every time you have a chance to capture a memorable piece of your family holiday history. Interview the kids

Young and ghoulish: Halloween is most kids' favorite holiday and a perfect opportunity to capture their "unnatural" personalities on videotape. To get the before-and-after effect, shoot the dressing and making-up process as well.

on what they love about the holiday. Shoot them doing whatever they like to do during the season. Remember to tape the small, revealing moments as well as the major events. Close in on the *specifics* and *show them.*

School Events

In addition to everything I discussed above, especially the virtue of isolating particulars and showing them, there's something important to anticipate before shooting plays, sports competitions, and other school events. When you show up at the event, it's frequently difficult to find your own children among all the other kids. You could be standing there in line with the other video parents, ready to roll tape, only to realize you don't know when and where your kid is supposed to be.

The predicament can be avoided easily by making the early effort to attend a practice session. Afterward, you'll know where to stand in order to get the best shots, when to start shooting and whether you'll need accessories such as a telephoto lens or an especially sensitive microphone. The time and energy will almost certainly be worth it. No matter if your youngster's portraying a butterfly for a matter of 60 seconds, you know how proud the kid will be. Don't disappoint your child and yourself by blowing *your* part.

At the same time, remember that this is your kid's show, not yours. Stay on the sidelines, both physically and psychologically. Sometimes, the sight of overzealous parents waving cameras around can be downright humiliating to children, especially as they approach their teen years. So settle for a simple movie with a minimum of elaborate moves and set-ups, and try to use a telephoto lens, in order to maintain your distance from the kids. Remember, you're on your youngster's home turf now, and that fact deserves your respect as much as you require the kids' respect on your territory.

8

SLICES OF LIFE:
THE ELOQUENCE
OF EVERYDAY EVENTS

A sliver, a chip, or a scoop can't compare with a *slice* of life—a perfectly proportioned sample of every element in the whole. Individually, the different sides, the surface, and the substance at the center of things may each be important in its own way. But separate views of separate aspects never show the whole shebang, and home movies of the holidays, special events, and other individual highlights of family history don't depict life accurately. Simply because they are special, those special events cannot possibly provide a full, true picture of your family. For that, you need to videotape all the important elements of life, including the evocative, ordinary incidents that happen every day, to cut down deep and clean, and get a good, thick slice of life.

A selection of scenes straight from an individual's life can be incomparable in conveying all the different dimensions that make up a personality. Record a representative sampling of someone's day-to-day activities, a video notebook of natural behavior—playing games, doing chores, arguing, relaxing with a hobby, telephoning friends, working, complaining . . . the good, the bad, and all that's in-between. And you'll have a portrait as interesting and special as that unique individual.

Allen Funt, the creator of "Candid Camera," explained the merit of spon-

taneous camerawork to me. "People are fascinating and amazing to watch when you see them acting naturally. This is true of children, especially. Kids are so uninhibited," said Funt. "Point a camera in somebody's face, and it's all over. People suddenly turn into who they want to be, instead of who they really are. They only let you see one side of them—the part they think is their best. It's not necessarily [their best side, however]."

In his classic TV and videocassette programs (Vestron Video), Funt managed to catch unbridled human behavior by concealing his camera somehow, be it in a phony air vent, behind a two-way mirror, or across the street by use of a telephoto lens. Although few American homes have phony air vents or two-way mirrors, Funt's approach can be adapted to home video moviemaking. Instead of hiding your camera in a potted plant, you need to keep your shooting understated. Play it down.

From the outset, don't prep your family for the shoot or try to psyche them up for "acting natural"; that's counterproductive. Also, keep your camera as far from your subjects as possible and out of their field of vision. Try shooting from the side. As an extreme example, tuck your equipment in a corner on a tripod, and *let it roll.* Stay away from the camera and don't touch it again to fiddle with the controls or change camera angles. Do whatever you would be doing at that point if you weren't taping. If that means stepping in front of the camera and getting in on the family activity, do it; if it means leaving the room and ignoring your whole set-up, force yourself to do that. In the end, you'll have much too much footage, which you'll have to edit down. But at least a few minutes of that footage might capture your family, as Allen Funt says, "in the world's greatest act—people simply being themselves."

To get the best slice of your family's life, you need to select the moment carefully. Every second of your existence isn't necessarily tape-worthy. Although you should shoot those "evocative, ordinary incidents" that happen every day, those ordinary incidents should evoke something *distinctive* about someone in your family.

Let's explore an example. What's your family doing right now, while you're reading this book? Let's say the kids are fast asleep, and your spouse is writing checks. It's the most boring, tedious example I could think up. Definitely not worth taping, right? Well, stop to think it over. *If* your family finances happen to be a particularly important or interesting aspect of your life at this particular time, the household budget could become the centerpiece of a worthwhile shoot. You'd have to make the effort to bring out whatever's notable about the budget these days; perhaps have your spouse

talk over what you're spending too much money on or what investments you might look into. Is this the time to buy that vacation home? Or had mom better go back to work? If any topic as dull as the budget has sufficient meaning to you, it could make a sufficiently meaningful movie. Just keep it short—no longer than two or three minutes. Many aspects of family life make for valid time-capsule vignettes, so long as they're pointed and brief.

Here are a few more dramatic slice-of-life movie ideas, along with a few tips for shooting them:

Learning to Walk

Many efforts to shoot children's first steps display the parents' degree of emotional development more vividly than the kids' physical development. Never push your children for the sake of getting good footage. Tapes of first steps and other milestones in a child's life often require a great deal of time and patience. The most responsible approach is to set the camera up on a tripod, slip in a long-playing cassette, and let it run for an hour. Meanwhile, create an upbeat, comfortable atmosphere that might be conducive to encouraging your child to walk (or perform whatever other monumental activity). If you get a minute of what you wanted, edit it out, erase the other 59 minutes of footage, and consider yourself a great moviemaker and an even better parent.

Or, simply wait a month or so until the child is walking with a little proficiency. By that point, your child will need less of your attention to be safely and securely ambulatory. And, I assure you, he or she will *still* be as cute as a month earlier.

Toddler Talk

Shooting a child's early words involves the same pitfalls as taping the first steps. Again, patience and sensitivity are paramount. Don't apply undue pressure. After all, toddlers talk best when they have something to say—when communication is either a necessity or a game, not an executive command. As with taping early steps, go for maximum coverage with a tripod and long-playing cassette. For the best possible results, use a wireless microphone, if you have one, clipped onto the child's clothes. Wireless mikes allow you to capture everything kids might say while you're taping, no matter how softly they speak or whatever direction they turn their heads.

Bike Riding

Learning how to ride a bike is not only somewhat dangerous, but also genuinely terrifying for many kids. Don't intensify the trauma by pointing a camera at your kid unless you're unwaveringly confident that the child won't mind. Play it safe: wait a while until the kid is comfortable and adequately proficient with the bike. Don't worry about missing the excitement bike-riding holds for a child; that won't disappear until it's time for a driver's license.

When you do try shooting a bike-ride, avoid standing along the side of the child, shooting perpendicularly, with the kid riding from one side of the frame toward the other. You won't get enough footage that way. Instead, stand far ahead of and directly in front of the child. Start shooting with your zoom lens extended to fill the frame with your child, full-body. Then pull the zoom back steadily at the same rate as your child's approach, maintaining the exact same full-body framing. This method will give you maximum footage and a dramatic effect while showing your youngster's face the whole time. Just try not to get run over while you're at it.

Starting School

Some kids love the first day of school. For them, shooting a movie of the event can augment the excitement perfectly. Other kids go whimpering, whining or worse. For their sake, keep that camera velcro'd tight in its case. And, whatever you do, never walk into the school with your video camera on your child's first day, unless the kid is clearly thrilled about the prospect. School is your child's territory; don't violate it by pulling a major grown-up attention-getter like making a home movie, especially on that momentous first day. You could easily embarrass or stigmatize the kid, whether or not you realize it.

The wisest approach may be to treat the subject of starting school without depicting the actual event. There's nothing wrong with working *around* a topic; that's frequently the only way to see every side. For instance, shoot the children playing on the last day of summer vacation. Ask them in advance if they'd like to do anything special or say "so long" to any of their summer friends. That evening, interview the kids about the upcoming day and capture them preparing for the big event, whether by packing their lunches or praying for a premature blizzard so the first day will be cancelled.

Moviemaking Movies

Here's a strange-sounding idea which usually works wonderfully. When the kids are old enough to operate the video camera themselves, borrow or rent a second camera and shoot them shooting their own original production. The beauty of the project is that it has an unusual, built-in climax—the finished movie-within-a-movie.

Teen Activities

To a teenager, seeing a parent with a video camera is very much like seeing the walking Angel of Death. You can do no right with your video equipment—or without it, for that matter—in the eyes of your kids after puberty. Still, you will probably want some footage of the kids as they experience one of the most dramatic phases of human life.

One solution: let teenage kids shoot their own movies. Lend them the video camera to tape whatever they want with their friends. Keep cool. Trust them. When you willingly do so, they're more likely to prove that they deserved your trust. But agree on one firm ground rule, in addition to their axiomatic responsibility for the equipment itself: The kids *must* play whatever they shoot for the entire family to see.

You will probably be in for a treat. I've seen a few startlingly imaginative and smart video movies made by teens, as well as some productions about as dumb as most adults' movies. My favorite, shot by a boy from my hometown high school, was a spoof of the old Busby Berkeley musicals, which starred dancing hands in place of chorines, and came complete with choreography, overhead shots, and a miniature stage made with gumball footlights.

By the way, if you'd like to encourage any teens you know to try making a movie, you might recommend they read a charming teen novel called *Long Shots* about a group of girls making a home movie. It's not only the only novel I know of about home-moviemaking, it was also written by my wife, Joanne Simbal.

Of course, there are countless memorable events and activities to shoot over the course of your kids' lives, such as hobbies, clubs, sports, sales campaigns, dates, camping, picnics, broken legs, trips, sleep-over parties, visits from out-of-town friends and so much more. I have no intention of attempting to list them all. My goals here are more tutorial than encyclopedic;

by touching on the key ideas, I want to help you think about your family life creatively in terms of your home-movie possibilities.

Finally, don't stop taping the slices of your life. According to video manufacturers, camera owners tend to use their equipment compulsively for the first six to 12 months of ownership, with use declining slowly over the following two years. Then, camera activity suddenly drops to a virtually dormant level. To fight this video attrition, anticipate the problem and plan ahead to avoid it. Keep taping at regular, established intervals, such as every three or four months at most. Make shooting a habit. Otherwise, you may look back at your movies one day and find yourself with years of your life missing.

9

STORIES:
CREATIVE
CONCOCTIONS

Children love to play pretend, almost as much as grown-ups do. At very young ages, most of us are miraculously deft at make-believe, changing characters from superhero to movie star to scientist in a blink. By adolescence, we're busy experimenting with our personal roles, trying out all sorts of traits for a while. Eventually, we succeed in building adult personas satisfying enough that we sustain them for the rest of our lives. What a great group of actors humanity is. We were made for home movies.

It's only natural that families want more interesting ideas for using their video cameras once they've exhausted the standard subjects, the domestic clichés. Soon, some people lose interest in home movies and all but forget about their cameras until holiday time. Others take the initiative to try all sorts of imaginative video movies, among the most creative of which is the production of complete fictional stories with everybody in the family acting out a part.

The simplest movies of this type to make are enactments of famous stories familiar to everyone in the family. Ask the kids what particular tale they'd like to shoot; they'll deafen you with ideas. Most likely, the kids will lobby hardest to portray their favorite characters of that week, as opposed to doing *Swan Lake*. And what's the harm, so long as their latest fave characters aren't sinfully vapid role-models? Use your judgment to select one of the kids' story

suggestions, evaluating both content and moviemaking practicality: so long as you decide upon a specific *story* to shoot, not merely a set of characters to play.

The possibilities are as great as the number of great stories for kids. You can choose among the classic tales from Mother Goose, the Brothers Grimm, or the Bible; history-based accounts of figures such as Marco Polo, Marie Curie, or Thomas Edison; or contemporary stories from children's books, movies, or TV programs with characters such as the Berenstain Bears, the Muppets, Superman, and all the others.

Because you're working in the video medium, you're likely to find your family drawn to ideas related to that medium, such as your own versions of favorite TV shows and movies. There's a certain consonance to watching your family on TV doing things you're used to seeing on TV. It's self-referential video, and it's one of the most natural ways to go, if not necessarily the most creative.

To progress further in the telling of established tales, you can have your family follow the actual dialogue from well-known plays, by using published scripts. Most major bookstores and libraries carry a variety of scripts of vintage and popular stage plays, including many titles apt for kids of most age groups. If you look well enough, you should be able to locate most favorites, from recent hit musicals such as *Big River* and *Annie* through perennials such as *Harvey* to the Shakespearean classics.

Owing to the likely limitations of your shooting schedule (and the attention spans of your cast and viewers), you'll rarely want to shoot full-length plays in their entirety, let alone complete musical productions. Instead, individual scenes from most good works should hold up as adequate dramatic units. Better still for home-movie purposes, a number of anthologies of one-act plays have been published over the years, principally for academic use.

Although screenplays of feature films and TV movies as well as scripts of radio plays are also widely available, I wouldn't urge home moviemakers to try working from them. They tend to include rapid changes of setting and elaborate instructions impossible to follow on a home-movie shoot and a home-movie budget. The major virtue of stage plays as source material is their inherent simplicity to set up and shoot. (For help in locating books unavailable in your area, contact the Drama Bookshop Inc., 723 Seventh Ave., New York, NY, 10019.)

To get more inventive, you might want to try choosing a familiar story as a basis for your movie, then change it around in imaginative ways. In other words, use the basic outline of a famous tale as a guiding structure for your

own update, adaptation, or spoof of the story. For example, you could take the story of the bread-baking Little Red Hen and adapt it to tell about any type of character creating any object, from a toymaker to an adventurer building a snow castle. Similarly, you could turn the story of Pinocchio into a tale of a robot boy tempted by nefarious aliens. Why not? *King Kong* is *Beauty and the Beast*; *West Side Story* is *Romeo and Juliet*; *Red River* is *Mutiny on the Bounty*; even *E.T.* is essentially *Snow White*. (Think about it.) The process of adaptation is as old as storytelling itself, although the professionals refer to it as paying homage instead of stealing.

The ultimate approach to putting on an original home-movie production is to write a script yourself. Either working alone or, preferably, collaborating with the kids, you can create a unique story customized to the abilities of your own family and friends. To work up your story, ask yourself: How many kids want to be in the movie? What special strengths can they show off on-camera? Are there any odd objects around the house that could be used as props? Put the answers together, and what do you get? A tale of a soccer player, a math whiz, and a TV nut—and what they do with a big, ugly, empty paint drum.

You can do much better than that, without trading in your kids for the cast of *Fame*. Try some ingenuity or, in the absence thereof, get the kids to help. Put all your heads together and ask yourselves some more questions: what genre would you like to work in? (Drama, comedy, sci-fi, musical, historical, Western or an unusual amalgam of them?) What kind of story would you like to tell? (A romance, mystery, adventure, chase or good guy/bad guy battle?) How long is the movie going to be (five minutes or half an hour)? What locations are available to you? Has anybody in the family ever made up a story for school or pleasure that could be adapted as your movie?

When you put all that information together, as if on a Chinese menu for moviemaking, you'll come up with *some* movie idea. At that point, concentrate on fashioning a cogent structure for the movie, then be sure the thing makes sense and builds with strong momentum. Finally, fill in the story skeleton with individual incidents of action and lines of dialogue.

If the story is complicated or you're very serious about doing a terrific job with it, I'd even suggest you sketch some rough pictures of your key shots in sequence, with lines of dialogue or notes scribbled beneath your drawings. This is called creating a *storyboard*, and I don't stress it in this book because it's too much involved a process for most parents' purposes. But if you get extremely ambitious about a particular project, a storyboard can serve as a valuable map through your storytelling territory.

Sketchy plans: Instead of winging it, plan your story carefully. At a minimum, jot down an outline of your ideas for each sequence. To go all-out and prepare your production like the pros do, you could even sketch out your entire movie, shot by shot, in a comic-strip style "storyboard." Here's one I made for a home movie called *The Adventures of Superkid.*

continued

That's not all there is to both the art and the craft of playwriting, of course. But I won't pretend to be able to teach anyone how to become a playwright in one brief segment of this book. If you're all that serious about scriptwriting for your home movies, take some playwriting texts out of the library and study up. It'll help you enormously. It won't hurt, though, to start by getting the whole family to pitch in, sticking with the basics, and giving it your best shot.

Storyboard overboard: No matter how carefully you plan a movie, it will always come out a little different once you start rolling the tape. Note how these shots from my kids' actual production of *Superkid* differ from the original storyboard on the previous pages. Which is better: the storyboard or the movie? The movie, of course—simply because the whole family had fun making it.

1

2

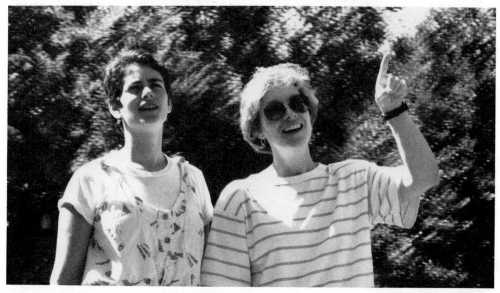

3

4

5

6

By the way, here's how you can get Superkid to look like he's soaring through the air. Just leave dad out of the picture, of course.

10

SPORTS AND GAMES:
PLAYING FOR KEEPS

"Shooting sports is storytelling." Words to shoot by.

They come from master storyteller Bud Greenspan, whose moviemaking subject is sports, but whose point is people. Greenspan knows how to turn heroes into human beings, a fairly rare talent in the world of sports moviemaking. Over a 20-year career as the writer-director-producer of *The Olympiad, Jesse Owens Returns to Berlin* and many other acclaimed productions, Greenspan has developed a highly humanistic approach to shooting athletes and athletics of every type. His perspective is unique, so I asked him for some insight into shooting home movies of kids playing sports.

The one overriding principle, according to Greenspan, is to "humanize the sport." Citing as an example his coverage of the 1984 Los Angeles Olympics, Greenspan said, "We didn't care if we shot from the finish line of a race, in the back of the finish line or on the finish line at all. It was more important for us to show how the athletes *felt* about the race. We fought to get microphones on the runners during the four minutes before they ran. That approach shows that these individuals have identity as people, not just a group of fast bodies who zoom across the screen.

"Who can relate to Carl Lewis? Nobody. He's been depicted as a god up on Mount Olympus," Greenspan continued. "But you can relate to Edwin

Moses, who's comparable to Lewis, because of something we did when we shot him. When he won his 100-meter race, we showed his wife and the 47 seconds of anguish that she was going through as a loved one. Every woman—every girlfriend, sister, mother—could relate to that emotion. Meanwhile, the race was going on. We didn't even show the field. We did the race through the eyes of the runners's wife. She started to cry with happiness with about 20 seconds to go till the finish line, and you just knew Edwin Moses had broken away and was going to win, without seeing him at all."

If you're shooting an event like your daughter's backyard kickball game and she doesn't have a spouse just yet, there are many other ways to humanize the game. For specific examples, I asked Greenspan to use a typical home-video sporting event and suggest how to shoot it, scene by scene. "Let's take a Little League soccer game," he said. "If I were shooting it, the first thing I'd do is sit the little athlete down and say, 'What do you like to do, aside from soccer?' He says he likes to make his own ice-cream sundaes. So you take him into the kitchen, and you have him make a sundae for you. He might say he likes history. So you take him down to some local historical site and walk around with him and let him talk about history. What you're doing is establishing this individual's personality before he goes onto that field to compete, so that when he does and your son is up on that TV screen, everybody watching that tape will understand and care about that kid. The competition has no meaning if there's no set-up."

To round out that set-up, Greenspan added, "I'd talk to the boy's parents, to his brothers and sisters, to his best friend, to his little girlfriend, if he has one. Get some tape of his teacher saying, 'I wish he'd spend more time with his books. All he wants to do is play soccer.' Present a totality of his life.

"Then, when you're finally shooting the actual event, get some shots of mom or dad's eyes during the game. In the end, you'll have humanized the sport and, hopefully, touched upon the meaning the sport has for your child."

To apply this emotion-oriented approach in practice, a couple of production details come into play. One is *narration*. You can always add commentary to a video home movie by speaking at normal volume while you're taping; the camera's built-in microphone should pick up your voice clearly. Alternatively, you can use your VCR's "audio dub" feature, assuming you have a machine with this capability, to add narration to a finished tape. With either method, narration can serve to add sense and continuity to a home movie of sports which may otherwise be hard to follow—especially if you're occasionally showing family members' faces instead of the on-field action.

Titles serve the same basic purpose as narration without obfuscating the sound of your on-screen subject matter, as narration can. The most versatile titles can be created with a *character generator* (an accessory that produces words or numbers on a videotape), including titles superimposed over the video action. Still, titling can be accomplished by means as simple as shooting a sheet of paper with words or numbers (for scores and statistics) lettered by hand.

In terms of content, both narration and titles should always be complementary, never redundant. In short, don't describe what you can see. Overloading the senses with duplicated input doesn't stimulate; it anesthetizes. For instance, when your daughter walks up to the plate to bat in her first Little League game, *please* don't say, "Here she comes walking up to the plate to bat." That much is obvious. Instead, enrich the action by thinking of something that's pertinent but not apparent, such as, "She's been practicing that swing for months now, and it really shows."

It's okay to be dramatic, but don't get *melo*dramatic. Let's say your son's the quarterback in the State Championship football game, his team's behind

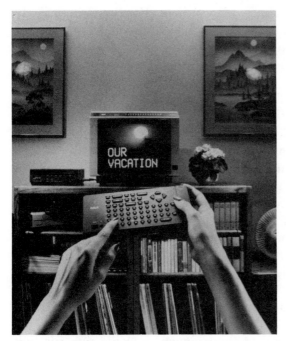

Words and pictures: An electronic *character generator* creates the snazziest home-movie titles, when they're necessary, but there's nothing wrong with writing on a plain sheet of paper and simply shooting it with the camera.

by one touchdown, and it's fourth down and goal to go with five seconds left. A once-in-a-lifetime moment, obviously. And I repeat: *obviously*. Resist the urge to say, "Here it comes—the greatest, most important single event in my son's entire life . . . " Similarly, don't superimpose titles saying something like "The Big Moment." The drama of a genuinely dramatic moment should be evident. If you want to add a verbal touch as a means of complementing the action and not merely releasing your own nervous energy, try something informational, such as counting the remaining seconds of play.

Played-for-Video Games

Beyond the use of video as a passive means to record your children's usual sports and games, the medium may be employed to initiate unusual new games. Moviemaking then becomes an active, integral part of game play. Consequently, the kids get involved in the shooting process as the parents get involved in the game.

An easy, accessible example of this type of played-for-video game would be something based on a familiar TV game show. Your family would plan, play, and produce the game as a home-video project. For the structure, the questions and the other particulars involved in such a game, home board-game editions of popular TV games are very complete and generally inexpensive (less than $15 apiece on the average). Most board games even include miniature props such as spinning wheels and flipcards which can be shot in close-up for a surprisingly slick effect.

Should you now use a board game as the basis for your taped game, the sort of questions (or hidden phrases or other challenges) used in the majority of TV games are easy to make up yourself. Just remember that if you have very young elementary-school children in the house, they should make up all the questions; this way, the intellectual level of your show will definitely match, or exceed, that of most successful TV game shows. Among the dozens of current or recent game shows sufficiently familiar to most kids, some of the ones especially adaptable to home-video production include "Jeopardy," "Wheel of Fortune," Password," "The Price Is Right," "Name That Tune," "Can You Top This?" and "Family Feud."

As a final thought on this subject, I suggest you don't dispense with prizes. Come up with some imaginative, inexpensive awards for which your particular brood would strive, such as a week without chores, a night of staying up past bedtime, or a cassette movie rental of their choice. Specific rewards help

spur the competition that gives a game a distinct spark. For better or worse, we're part of a culture that thrives on competition, ego, and greed. Here's a precious opportunity to use and control that regrettable reality in order to serve a larger purpose—to get everybody in the family to spend some time enjoying each other's company.

III

ON LOCATION

11

INDOORS:
DESIGN FOR INTERIOR TAPING

There's a colorful old Hollywood legend about a mysterious fellow named Harry who could always be found in a different spot on the enormous MGM backlot—painting a set, patching a prop, or otherwise tinkering with the seemingly interminable movie-production apparatus. Harry didn't work at the studio, though. He *lived there*, surreptitiously sleeping in the sets for *Grand Hotel* and sneaking a stroll alone down the Yellow Brick Road.

Apocryphal or not, the tale holds a lesson for video moviemakers. Harry could have made one hell of a home movie in his particular residence; but everybody else on earth has it a whole lot harder. The typical home, like most indoor settings, can be a hostile environment for moviemaking. Working without the benefit of a strictly controlled studio environment, home moviemakers are subject to the idiosyncracies and limitations of indoor light and sound.

Light

Every room has its own light characteristics—overall illumination, bright spots, dark spots and other more arcane details largely irrelevant to home-moviemaking. Fortunately, most video cameras produced since the mid '80s are highly automated and calibrated to accommodate average home lighting

situations. Unfortunately, you'll probably never tape a single movie in a room whose every light characteristic falls neatly within the median ranges upon which your camera was factory-calibrated. You'll almost always find at least one element of concern related to lighting—a glaring lamp, a dim corner, an unwanted reflection.

Your first job related to home-movie lighting (or the first job of your family lighting director) is to assess the light characteristics of your room. To do that, you must make a conscious effort to see as the camera sees. Otherwise, you're likely to compensate unconsciously for minor visual flaws; at a casual glance, everything will look okay, then you'll replay your movie and discover problems when it's too late to do anything about them. Such is the fabulous sorcery of perception; and such, as John Stuart Mill might have added, is the drag with camcorders. Unlike the microprocessor-controlled empiricism of video gear, the mind's eye always sees what it wants to see, highlighting what we favor, softening what we dislike, filling in details that may or may not exist in mere reality.

How can you see like a camera? Easy: Decrease the aperture of your eye to increase contrast. In other words, *squint*. Give it a try now, looking up from this book. You'll find that every object around you looks significantly darker or lighter, with many details virtually disappearing. This is fairly close to the way your camera sees the world. Consequently, problem areas such as overly bright light sources and under-illuminated spaces should be easier for you to perceive.

Understandably, you may not choose to dart around the room squinting whenever you're making a movie. It's a strain on your eyes, and it makes you look like Richard Nixon. Still, I urge you to give the technique a try periodically to help you develop an understanding of what to watch for when assessing a lighting situation.

Practically all the problems you're likely to encounter are variations on too much or too little light. In instances of excessive light, you'll find two big hazards. One is glaring light sources, such as incandescent bulbs and candles. Keep your lens away from them *always*, at all costs, for practical as well as aesthetic reasons. If your video camera has a pickup *tube* instead of a solid-state pickup such as a CCD or MOS sensor (check your owner manual), aiming at bright lights will produce either streaks across your image area or "burn-in," in which a ghostly impression of the light source remains visible for some time after you aim away from the light. In severe cases, burn-in can damage a tube irreparably.

The second major hazard of excessive light is the problem of over-back-

lighting. This occurs almost exclusively when you're indoors shooting subjects in front of, or near, bright windows. If the outdoor area visible through the window is well lit, your camera's electronic iris will usually consider that area its primary image and adjust the camera accordingly. As a result, you'll capture the outdoor window scene splendidly while your subject appears in pitch-black silhouette. Although this is a distinctive device effective for shooting mood scenes or the opening credits of a James Bond movie, silhouettes are not recommended when your subject has a big nose. To avoid over-backlighting, don't aim toward bright windows; draw the shades or curtains; better still, if you happen to have a camera with an automatic iris control, adjust it to compensate for the "false" light reading.

As for inadequate light, every home moviemaker encounters circumstances when at least one portion of a room is not illuminated well enough to produce a strong video image, despite the excellent light-sensitivity of most video cameras. In such cases, the problem is usually easy to solve with some quick maneuvering of available household lamps or replacement of existing incandescent bulbs with other bulbs of stronger wattage. After all, home movies tend to look best when they look natural, as if nothing had been done to enhance the sights or sounds.

Still, your moviemaking environment (or your camera) may occasionally require the use of additional lights, in which case I implore you to use them sparingly. Don't make a time-consuming and probably obnoxious production out of lighting up the house like the Astrodome, like dad used to do with the old super-8 film gear. Do what the union lighting people do—namely, as little as possible.

On professional shoots, lighting directors generally apply the basic principle of "key" and "fill" lights—a basic, flexible approach useful in almost any moviemaking situation. The key light is the main, direct, overall light that essentially serves to provide illumination sufficient to render a vivid image on videotape. Its job is functional, not aesthetic. As a result, the key light can often create objectionable shadows.

To help soften those shadows, use smaller fill lights (of lesser intensity than the key lights)—keeping in mind the ambient light, the colors in the room (including the subjects' clothes), and the mood you want to create. One way of softening might be to place the fill lights at an angle roughly perpendicular to that of the key light. If, for instance, the key light is a 100- or 150-watt bulb ten feet in front of and one foot to the left of your main subject, a 40-watt fill light three feet in front of and two feet to the right of your subject could make your movie look like more than a moving mug shot.

Sound

As with light, sound characteristics vary markedly from environment to environment. Different rooms sound as different as they look. In hi-fi jargon, some rooms are "lively" or "wet," and they bounce sonic waves all around the room over and over again, producing hollow, indistinct sounds. Conversely, rooms that are "dead" or "dry" absorb sound waves instead of reflecting them, and the results are muffled and flat. Ideally, a room should be like a pet: neither too lively nor dead.

Before you start shooting a movie, you can fine-tune the sound of any room without a Herculean effort. To help absorb sonic energy in an overly reverberant environment, toss some pillows around, bring in a throw rug or two, or even tack up a wall hanging. To achieve the opposite effect in rooms that are excessively absorbent, remove items such as those above or bring in a few pieces of hard-surfaced furniture such as a glass table or some metal chairs from another room.

Going wireless: Despite the loud sounds of the wind and of other families playing in the park, Joanne can hear Jake clearly through her headphones. The little gadget with the antenna on top of the camera is the receiving section of a wireless-mike system. About 20 yards away, running around a meadow, Jake has the transmitting section hooked onto his shirt.

Every video camera includes a built-in microphone, so every one captures decent sounds at the same time as images. However, many conventional built-in mikes have a rude habit of overhearing unwanted ambient sounds such as the camera operator's breathing or adjusting of the camera controls, not to mention the noticeable motor noise of the camcorder's own internal mechanism. To avoid these problems, an accessory *boom* or *wireless* microphone is extremely beneficial.

Without a boom or a wireless mike, subjects anywhere within 20 feet from the camcorder can usually speak at normal conversational volume, and their voices will register satisfactorily on tape. Meanwhile, though, the camcorder's built-in mike may also pick up nonvocal sounds such as those made by radios, mechanical clocks and even fluorescent lights. With either a boom or a wireless mike, you should be able to capture conversation-level sounds two or three times as distant as those you'd be able to catch with a standard built-in mike. Just remember: both booms and wireless mikes are extremely directional, unless they're pre-set otherwise. They concentrate on the precise areas at which they're pointed, like aural flashlights.

(For more on specific video lighting and sound accessories, see Chapter 16, "Lenses, Lights and Microphones.")

12

OUTDOORS:
THE ELEMENTS
OF VIDEO STYLE

Mark Twain had the right idea. He wrote a whole novel, *Pudd'nhead Wilson*, with no weather in it. Not a single cloud nor any rain nor wind . . . no weather whatsoever. Now that would be the ideal way to make a home movie. Weather, after all, is far and away the most vexing aspect of shooting outdoors. When it's bad, weather can restrict your moviemaking maneuverability, dampen your family's spirits, impair your picture- and sound-quality, limit your shooting time, and shade the mood of your finished movie. When it's good, though, weather has the opposite effect on those things. Moreover, it's awfully fickle. All of which leaves one alternative for dealing with the weather when you're making home movies outdoors: You'd better find a way, like Twain, to work around it. Pudd'nhead Video.

Foul Weather

In the worst of weather—severe heat, cold, or wet conditions—you should almost always avoid shooting outdoors. Home-video equipment isn't cut out for it. As most owner manuals stipulate, a degree of climate control is essential to proper maintenance of electronics equipment as well as accessories such as microphones and cassettes. Excessive cold can damage lubricants and gum

up mechanical parts, while intense heat can burn out both camera tubes and solid-state elements, while also affecting lubrication. As a rule of thumb, try to keep all your electronics equipment at a temperature comfortable to *you*. The human body is also electro-mechanical, remember. If you're starting to numb in the cold or melt in the heat, your equipment is probably going through the same thing. (Many major professional electronics facilities such as the Advanced Product Evaluation Laboratories associated with *Video Review* magazine maintain a constant temperature of 70 degrees, with a two-degree variance.)

Often, however, the worst threat to your equipment is not the heat; it's the you-know-what. In damp or wet conditions, humidity can clog moving parts of your equipment and increase the risk of short-circuits. Listen to the weatherperson, or pick up a pocket barometer in a good hardware store. The optimum relative humidity for operating most home electronics gear is about 40 percent, give or take five percent.

In terms of home movie content as opposed to technical matters, the problem with inclement weather is the mood it inevitably establishes. Bad weather is a downer. As a consequence, you can either *use* the hostile elements for their intrinsic value or compensate for them creatively. By using them, I mean: Save that serious story you've wanted to shoot for a day when the gloomy weather matches the subject matter, or cook up a spooky tale to tell when the day is dark and stormy. Take Woody Allen, who takes this issue very seriously. He's been known to postpone production of a scene for weeks until the New York sky takes on exactly the right quality of miserable, dank oppression.

Just remember the technical perils of the elements when you want to go shoot your own exterior *Interiors*. You absolutely must make an extraordinary effort to protect your equipment before subjecting it to extraordinary conditions. If you live near a beachfront, take some time to shop the better photography stores in your area as well as a scuba shop. You'll find a wide selection of thermal, watertight housings designed for underwater photography which should do a thorough job of protecting your video camera from the dangers of both temperature and humidity. My only question for you is: What are you going to do to protect your *kids* when you're out on a cool, damp day with your equipment coddled safely?

Actual underwater moviemaking is far too complex a topic to take up here, but I can't resist making one point on the subject. A few years ago, I asked Jacques Cousteau for one tip to benefit home-video moviemakers: What's the most important thing to remember when you're shooting undersea? He

answered in one word: *l'histoire*—the story. Once again, the content should outweigh the shooting style or technical minutia, wherever you're making a movie.

Back to the bad weather. When you don't want to utilize it for its miserable intrinsic value or when you can't escape it—say, a joyful event such as elementary school graduation falls on a dreary afternoon—there are some specific ways for you to compensate for unwelcome weather. For one thing, don't show a lot of the sky in your shots; opt for medium shots, and fill the frame with your subjects. To go a step further, try battery-powered, portable lights to create highlights and contrast, which brighten the *feeling* of the shot by eliminating the flat, monochromatic quality of hazy days. (See Chapter 16 for more on home-movie lighting equipment.) Finally, on a human level, keep an upbeat attitude and set a positive tone for your movie to overcome the bad-weather blahs.

Sunlight

Naturally, the best condition for almost all outdoor moviemaking is clear, bright sunshine. It provides not only rich overall illumination and lovely, glowing highlights, but also a warm, comfortable ambience for shooting with the family, not to mention vitamin D! As a matter of fact, for the first few decades of film production, virtually everything was shot outdoors—including "indoor" scenes, which were staged in roofless sets under the sun.

Watch out where you point that camera in relation to the sun, however. If you aim toward the sun with your subjects directly in front of you, they will appear in shadow, dark and flat. Additionally, were you to catch a piece of the sun itself in your viewfinder, you could "burn in" a bright spot in your camera's pick-up tube, potentially *irreparably*. I'm not exaggerating. I saw the problem happen to my own brother Chuck, a photographer with longtime professional experience shooting still photos. (He shot all the photos in this book.) In the process of shooting a stunningly beautiful video sequence of the sun, he virtually destroyed a $1,500 video camera. That same stunningly beautiful image of the sun appeared in his camera for four full months, superimposed over everything he shot, until the spot finally dissolved away.

(As I explained earlier, burn-in and the related problems of lag or streaking occur almost exclusively with cameras employing image pick-up *tubes*, not solid-state sensors such as MOS or CCD devices. Check your owner manual.)

Conversely, I don't recommend you follow the old two-bit photo-lesson approach and shoot everything with the sun behind you. The flood of illu-

mination resulting from direct sunlight looks as flat and unflattering as back-lighting, only brightly so. Plus, it makes people grimace, so that they resemble Paul Lynde. The optimal position is with the sunlight falling on one side of your subjects. Such natural sidelighting provides visual depth and often ethereal highlights, and it's harmless to both your camera and your family's eyesight.

Outdoor Sounds

Sound also poses some problems when you're taping outdoors, much as it does indoors. As I discussed in the previous chapter on indoor shooting, a boom or wireless mike is a virtual must—in this case because you might be faced with unpredictable outdoor noises such as passing cars, planes and groups of chattering strangers.

Furthermore, never underestimate the great invisible demon of outdoor shooting: the wind. If your camera's built-in mike doesn't include a wind screen—the foam covering that slips over the mike like a fur hat—you're in for a big aural surprise. A gentle spring breeze you won't even notice while you're taping will end up sounding like the twister in *The Wizard of Oz*. But, if you only had a wind screen. . . .

IV

LEARNING WITH HOME MOVIES

13

THE LESSONS OF GOOD MOVIEMAKING

Can you learn much of meaning or value by making movies? Obviously—look at Ronald Reagan. Then again, look at Reagan's peers from his movie days: Bob Cummings, Dick Powell, Tim Holt, George Brent. What about those guys? Why didn't they ever become presidents?

To shamelessly oversimplify the subject, in homage to Reagan, plenty of other almost-talented, semi-famous actors may have had as much knowledge of the film craft as Reagan; but they didn't have one thing: his wife, a dedicated motivator who impelled her husband to apply his cinematic skills in a larger context. What Nancy Reagan did, for better or for worse, is something many parents (Republican or Democrat) might be well served to remember when making home movies with the kids. There's a lot to learn from the process of making movies, if parents recognize and reinforce the learning opportunities of moviemaking with larger goals in mind. Remember, Ronald Reagan likes to address his First Lady as "Mommy."

Potentially, home moviemaking offers an extremely diverse range of educational opportunities related to the variety of processes—cognitive, behavioral, and social—involved in the pastime. From the earliest planning stages through the final playback of a home movie, kids can learn from independent thinking, cooperation, observation, instruction, trial and error,

criticism and many other enlightening experiences. All along the way, parents have the opportunity to enhance every learning occasion, first by simply being alert to its learning potential, then by encouraging and reinforcing children in a manner appropriate to the given situation.

For specifics, here are some thoughts on six chief types of learning opportunities fundamental to home moviemaking.

Planning

The ability to comprehend complex relationships and the related ability to anticipate distant consequences of immediate events are two highly regarded gauges of intellectual development. In the course of well organized, conscientious home moviemaking, both abilities come into play. Consequently, the planning stages of family movie projects should be given almost as much attention as the shooting process. Make a point to set aside a block of time with the kids for exchanging ideas on what to shoot and how to shoot it, encouraging the participation of the children and guiding them toward visualizing their notions and anticipating the ramifications of their suggestions.

Thorough planning is frequently difficult, however, because there's a seductive appeal to the freedom, the challenge, and the tension of shooting extemporaneously. Indeed, impromptu production has a distinct value as an exercise in thinking on one's feet. The process does have a time and a place, but they happen to be *after* the kids have made enough movies conventionally to have a significant amount of moviemaking knowledge under their little belts. Improvisation is not as easy, as much fun, nor as rewarding to watch as it might seem. Every master improvisor, from Pushkin to Dizzy Gillespie to Robin Williams, has always worked with a deep understanding of and powerful control over the basic elements of his or her art, plus pure inspiration. Such a depth of understanding and control comes largely from experience, and that starts with planning. As for the source of that inspiration, God only knows.

Problem Solving

To help in developing the broadly applicable skills of problem solving, moviemaking has a great deal to offer. A lot of home movie projects turn out to be one problem after another. For instance, let's say you've still got half a story to shoot outdoors, the sun's setting, and the same group of kids won't

be able to get together the next day to finish the movie in tomorrow's daylight. What should you do?

Above all, keep cool. Don't immediately announce your own solution to the predicament in a divine decree. Instead, gather the kids together and ask them for some ideas, steering them toward sensible notions but remaining as objective and patient as you can be. Resist the urge to manipulate the kids into saying what you want to hear; although that might be the easiest route for both them and yourself, it's not the most motivational tact to take. Hash out all the available options. You might rewrite your story so it can end quickly; or move the movie to an interior location; or finish it a full week later when all the kids can get together again. Ask the gang: What are the merits and flaws of each of these propositions? And what further suggestions can the kids think up to sharpen their problem-solving faculties?

Creativity

Imaginative ideas, like effective solutions to problems, are well developed in a climate which inspires, nurtures, and reinforces independent thinking. An excellent way to start helping kids think creatively is, again, to get them to think for themselves. Beyond that, there's not a whole heck of a lot any parent can do to try to make a kid be creative. Simply give a child the necessary opportunities, the time and the love, and do so again and again. The more anyone gets to exercise any skills, the more those skills should improve.

Among all the academic theories about developing creativity, I have a fondness for one. It's not painfully cerebral, and it fits splendidly in the context of home moviemaking: the Fun Theory. Outlined in a treatise published in a 1987 issue of *The Journal of Personality and Social Psychology*, the theory asserts that having a lot of laughs plays a major role in inspiring creative thought. A study recently conducted at the University of Maryland in Baltimore, reported the *Journal*, showed that subjects who had just had a good time watching a funny movie solved problems requiring ingenuity more effectively than those who had watched a film about mathematics. The same kind of results might be expected to occur at home by telling jokes or using other means to put people in a jolly mood, suggests the report conducted by Dr. Alice M. Isen, who is now my favorite research scientist with the exception of the Bill Murray character in *Ghostbusters*.

Duel meaning: A tree-stump, a sword, and a little parental guidance can turn playtime into a subtle lesson about the Revolutionary War.

Academics

Most kids don't want academic subjects in their home environment any more than they want their families sitting around their classrooms. As a result, it's usually almost futile to try sneaking textbook subject matter into home movie projects. Kids can sniff out educational value straight through the sugar-coating, and it's just like poison to them.

I've seen some exceptions, however, in which literature, history, and some science were dove-tailed into home-movie projects based on literary works, historical events, and science-fiction tales with elements of fact. In every instance, the idea for the project was initiated by one of my son's friends—and this is essential, it seems. Among the aspects of academia to which many kids object, foremost is the fact that kids feel the stuff is forced upon them, which it is, of course. If you make it past that problem and manage to start

Injun trouble: This six-year-old is dressed up to re-enact Custer's last stand.

shooting a movie with a storyline, theme, or element of content pertinent to some academic subject, the project may have incomparable value as a learning experience.

Visual Literacy

As the American culture continues to grow increasingly visual, proficiency in visual skills becomes progressively valuable. This isn't the Pepsi generation; it's the Pepsi-*commercial* generation, in which electronic imagery is an omnipresent, almost omnipotent, force. Today, visual communication is on its way to ranking with readin', 'riting and 'rithmetic as the fourth fundamental skill of the electronic age. (I know "visual" doesn't start with an "r." See—verbal values are already decaying.) Obviously, then, learning how to make

home movies helps build skills in visual conception, design, and communication with bearing on daily life as well as value in preparing for future academic and career opportunities.

Interpersonal Skills

Which, when I was a kid, used to be called "being nice." Anyway, it is nice to get along with people, even if you consider the process a skill instead of a moral imperative. And, since making movies is such a highly collaborative endeavor, it absolutely demands cooperation, compromise, and sociability on the part of moviemakers. Everyone involved, from the director to the lighting director, needs to work efficiently and creatively in conjunction with each other. So everyone had better learn to get along, or you'll be enacting *Star Wars*, only off-camera. When you make sure to guide and reinforce the kids to interact with amity, honesty, and respect—this sounds mushy, maybe, but too bad—the result will be a better movie, initially, and better kids in the long run.

14

SOME HOME MOVIE LEARNING PROJECTS

To help target home movie projects to the specific learning needs and abilities of children at particular stages of development, here's a selection of movie-making ideas in 12 subject and skill categories for kids in four basic age groups. Of course, individual children tend to defy categorization by age—a youngster with certain advanced abilities may lag in other areas—so apply your judgment to select and to adapt the following notions as you see fit. Think of these as reference sources or stimuli for you and your kids to take off in your own directions with original ideas.

Ages 3–5/Nursery School–Kindergarten

Following Directions

Why don't pre-schoolers always do what you ask them to do? They find the alternatives irresistible. To a very young child, there are clear and immediate benefits to hopping on one foot or running away at the precise moment you want him or her to stand still and sing that song which you ordinarily can't get the kid to stop belting out. Meanwhile, in the child's mind, singing probably doesn't seem at all appropriate at that point. However,

once a child comes to understand the reasons for your requests and those reasons take on meaning for that child, you should (make that *might*) get better results.

Try this project for preschoolers: Ask the kids to act out one of their favorite stories, with each child assigned a specific role, clearly defined actions and dialogue. If your youngsters don't yet have the discipline or the attention span for this, it's definitely the project for them. The movie isn't supposed to come out perfectly—the first time, if ever. Let the kids make their mistakes; let them wander out of frame or change characters mid-sentence if they might. Then show the footage to the kids through your camcorder's viewfinder or your TV set, if you're indoors. Explain how the children's performances could improve next time—in encouraging, upbeat, and precise terms—and give the movie another try. Very young kids might refuse to go any further, and don't push them. Try again another day, and repeat the process of immediately showing the children their performances and encouraging them to improve. This is one of the best ways to use video technology's intrinsic qualities of erasability and instant playback for instructional purposes.

Sharing

Another important element in early childhood development, sharing, is easy to address in home moviemaking. Any project requiring kids to take turns on camera helps instill the discipline of give and take. Begin with a familiar children's game or song in which every child gets a turn to sing a verse, such as "Old MacDonald Had a Farm," and adapt it to home video. Make an MTV-type clip for kids, with everyone acting out the role of a different barnyard animal. Get the whole group in a long shot during the chorus, and close in on the individual children when it's time for each of their parts. While they're hamming it up and horsing around (sorry about the puns), the kids will be learning to share something very precious to them: attention.

Letters and Numbers

Bert and Ernie have this beat pretty much covered, but if you want to help them out, you can create your own "Sesame Street"-style movie game to give the kids some hands-on fun with letters and numbers. Here's how it works: Without the kids, shoot a tape that shows every letter of the alphabet (each drawn on a separate sheet of plain paper), followed by a shot of an object in your house that starts with that letter. Pronounce each letter and the word as narration. This tape will serve as the basis for a game along the lines of a scavenger hunt.

Gather a group of kids together, and play the first (letter A) segment of the tape. The youngsters then have to race each other to find and name an object in the house (*other than* what they just saw on screen) starting with the same letter. The first child to locate and identify an item correctly earns one point, and the one with the most points at the end of the alphabet wins. Alternatively, the same basic game can be played with numbers, whereby the kids must find groups of household objects (two pictures, six chairs) adding up to the number shown on screen.

If you don't need to keep your camera hooked up to your TV in order to show the original letters tape, shoot the kids as they're playing and add extra excitement to the game.

Ages 6–8/Grades 1–3

Reading

If you think video isn't an effective means for teaching reading, try to tell it to a first-grade teacher. You'll find out that long before most kids start class, they can already read dozens of words and terms such as *stay tuned, coming next, new and improved, Mattel, Smurfs, McDonald's,* and everything else that's repeated like electronic mantras into the sentient eyes and ears of kids. It's the cathode age, and why fight it? *Use it,* instead.

In this era of maxi-merchandising, books based on the most popular kids' TV and movie characters are widely available. Other books for kids are also published despite the fact that they're generally superior. Whatever your children's preference, take one of their favorite books and base a home movie on it. But here's the kicker: Dramatize half the scenes in the book with your kids acting out the roles, and use the actual text of the book to tell the other half of the story, alternating from live action to text every few minutes. You can zoom in on the book (optimally, employing "macro" focus, if your equipment has the feature) to shoot the text. As a result, the kids will have to read along with the on-screen text to follow the story.

Writing

Turning around the above idea, the kids can help make an unusual movie they may find very funny—actually, punny. Children love silly wordplay, and you can employ it in a movie that speaks the kids' own language while it motivates children to practice their handwriting. To start, ask the kids to help you think up some goofy puns—common phrases with weird double meaning, such as "salad dressing," "butter fly" or "block party." Should you

run into a stalemate, or a stale mate (see how I've mastered the technique?), pick up a children's joke book with a section of puns. Next, ask the kids to hand-write each of the funny phrases on a separate sheet of paper. Shoot these title cards with accompanying voice-over narration such as "Have you ever seen . . . salad dressing?"

Then have the children create little vignettes to *visualize* the jokes. For example, one child can put doll clothes on a head of lettuce (salad dressing); another can move a package of butter through the air (butter fly) or pretend the kids' toy blocks are dancing (block party). On tape, show the material in this sequence: title card (with narration), sight gag, title card (with narration), sight gag, etc. When you're finished, you'll have a video compilation of the kids' own jokes for them to enjoy. I know it's childish, but remember, so are children. Besides, in this case, the moviemaking means—the writing—justifies the end.

Arithmetic

Like writing, arithmetic is a tricky thing to work into a home movie. Few kids will whoop with uncontrollable glee when you say, "Hey everybody, let's make a movie about long division!" My advice is to sneak some simple mathematical tasks into the moviemaking project without focusing undue attention to the matter. For instance, a modicum of math is necessary to plan a movie that centers around achieving a particular goal within a prescribed amount of time. Think of a western like *High Noon*, wherein the hero counts the minutes until the bad guys' train is due to pull into town. In an adventure flick, a bomb might be set to go off in 15 minutes. Maybe a spy has to uncover ten hidden objects within ten minutes. Cook up any situation of this type, and work as much simple addition and subtraction as possible into the preparation process as well into the movie itself, making sure to ask the kids to help you with all the arithmetic.

Ages 9–11/Grades 4–6

History

Academic material is far and away the most difficult to incorporate into home movies, as I discussed previously. Still, it can't hurt to *try* using some history or other academic material in your movies, granted that your expectations are realistically modest. Face it: Kids do not stay awake at night fantasizing about re-enacting the signing of the Magna Carta. Most youngsters

do like adventure stories, however, and some of the greatest are based on historical persons and legends. Focus your efforts on them. Shoot a time-travel movie, and have your hero join in the adventures of Cleopatra, Robin Hood, Christopher Columbus, Wyatt Earp or other figures from history. Guide the kids, too, with some story suggestions based on the real activities of those figures. Look up the individuals in an encyclopedia, and have good ideas in mind by the time you start mapping out the movie.

Science

Easy: Put on a magic show. Not a science show—that's too nerdy. Rather, apply some science in a series of fanciful tricks performed by one of the kids decked out as a magician. *The Great Kidini!* There are dozens of safe, simple tricks of this sort, outlined step-by-step in paperback magic or fun-with-science books available in most libraries. Many elementary-school teachers know plenty of the same tricks. Here's an example: The family magician asks for a handkerchief or other small cloth article from the audience. After passing it around to prove the cloth is perfectly normal, the magician crumbles it into a ball and, with a flourish, tucks it into a clear glass. He or she turns the glass upside down and submerges it into a bowl of water. Then, *voila*—when the glass comes out of the water and the handkerchief is removed, it's completely dry!

How did it work? That question, of course, is the whole point of shooting a movie like this. Make certain to explain the trick to the kids, and they'll come away with a very vivid memory of basic scientific principles (in this instance, regarding gravity and the mass of air).

Finally, a shooting tip: Record this type of trick in one long, continuous shot, or your viewers will assume you stopped the camera and pulled some electronic *legerdemain*.

Geography/Social Studies

Shoot *Around the World in 20 Minutes*—a globe-trotting adventure with your kids encountering children from all over the world. This will take some simple props and costumes, such as umbrellas (parasols) for Chinese passersby and towels (turbans) for Indian nobility, not to mention ingenuous camera angles for avoiding your home-town backgrounds. Also, parents: As with the time-travel movie, you might do well to brush up on your own social studies, so as to be able to impart interesting information to the kids while planning and shooting the movie.

Ages 12–14/Grades 7–9

Current Events

As much as they hate to watch the news on TV, kids seem to love doing their own newscasts on home video. I'm not sure why, although I have a suspicion it has do with the joy of ridiculing the grown-up world. Fair enough; the world deserves it, which is why social satire has been so popular from Lewis Carroll and Mark Twain to *Mad* magazine and "Not Necessarily the News." Let your own kids try their hands at spoofing current events, local, national and international, in a satirical kitchen-table news show. But, again, be thoroughly prepared to offer the youngsters some ideas and tips for content, leaving the satirical spin entirely up to the kids. You might end up being surprised at exactly how piercing young minds can be.

Literature/Drama

The obvious and ideal approach is to make a home movie based on a book or a dramatic work of recognized merit. Unfortunately, kids will rarely be interested in doing that, unless they don't realize the material meets adult approval.

As an alternative, here's an unorthodox notion: The next time the kids want to act out one of their favorite stories in a home movie, see if your local library has a dramatic version of the story—a published script. Most people outside the theatrical world don't realize that many popular books and films are adapted into plays for use among regional and school theatre groups. If possible some day, shoot a movie directly from one of these published scripts, following the dialogue and the stage directions as closely as you can. Your movie won't take on the literary depth of *King Lear* merely because you're working from a book, but the project should have a legitimate degree of value as a first-hand lesson in dramatic structure, stagecraft and language.

Music

This is one of the easiest topics of all to treat on home video. Most kids love music, particularly horrible music, and they think of music as a visual medium, thanks to MTV. Yet, your own music movies don't have to be mere copies of Def Leppard clips—what I call Empty-V. The kids should stretch their imaginations, with your help, to shoot all sorts of home movies incorporating music, from mini-concert performances and sing-alongs to full-scale musical production numbers.

If you have any budding instrumentalists or vocalists in the family, shoot them as often as possible, even if you erase or edit some of the tapes. The on-camera practice will do the kids good, and the resulting tapes may someday be a precious record of the kids' progress on their instruments over the years. And if you don't have aspiring young musicians in the house, the entire family might enjoy playing home-video music games, such as your own version of "Name That Tune."

15

VIDEO IN THE CLASSROOM

I remember shuffling single-file into the gym of Brensinger Elementary School. My class, the third grade, got to sit fairly close to the front, with only the first and second grades ahead of us. Still, I couldn't see much—a glow of gray-blue in the corner of a portable TV set—and I wasn't sure what I was supposed to be seeing, anyway. But I was sure of one thing: *I was watching TV* in the middle of the school day, and that was *really something*. No matter that the show was about astronauts and not Roy Rogers. There was a thrill to watching the first space flights in school that had much less to do with one man's flight out of the world than it had to do with children's everyday flight between two worlds—the worlds of home and school.

Like most kids, I grew up with the feeling that TV just doesn't belong in school. TV, I always thought, is part of home, like family and the refrigerator and walking around in your underwear; and it's a part of everything home represents, such as security and nurturing and fun. School, I thought, is a different world—of books and blackboards and the girl in front of me (Doreen Brower), and everything they represented, such as knowledge, discipline, and socialization. These feelings aren't mine alone, I know. When my son was four, my wife rejected one pre-school for him because it had a VCR in the playroom. Of course, the pre-school we chose had a VCR, too, although *its* was in the science room.

As an almost mature person and one-day-a-week teacher now, I've learned that home video offers a superb opportunity to bridge the distinct worlds of home and school, and is an excellent aid in the educational process. When video is introduced in the classroom, I've found, students tend to react much like my third-grade colleagues and myself during the Mercury flights. You can see the thrill in their faces and their body languages. Get out the camcorder, and it's almost as if you rolled out a refrigerator full of junk food—with the critical difference that the teacher can take advantage of the video medium for a range of educational purposes, by planning and controlling the use of the technology to motivate and enlighten the students.

Whether in the home or in the school, video moviemaking offers educational opportunities in the same six fundamental areas of learning—planning, problem solving, creativity, academics, visual literacy and interpersonal skills. (See page 83, "The Lessons of Good Moviemaking.") Similarly, whether in the home or in the school, video projects should be tailored to the learning needs and abilities appropriate for children in each of the four basic age groups, such as sharing and letter recognition for pre-schoolers, and reading, writing and arithmetic for grades one through three. (See page 89, "Some Home Movie Learning Projects.") In school, however, the constraints of time, mobility, and budget as well as the dynamics and the social structure of the classroom require that teachers target video projects to accommodate their demands. Accordingly, here are specific suggestions and guidelines for classroom video projects, in two basic categories, for use by children from preschool through high-school ages:

Training Tapes

The most elemental application of video in the classroom is as a means to document children's skills in areas in which progress can be gauged visually. For instance, teachers of subjects such as physical education, music, and speech can set up cameras on tripods and have children's performances recorded during class sessions. Here, I recommend use of tripods for two reasons: one, to free up teachers so their attention can remain focused on the student; and two, so as to not overemphasize the camera and apply undue pressure in situations which may already be stressful for many children.

The benefit of documenting a student's performance at something like the parallel bars, for example, lies in providing the child with an opportunity to examine his or her own performance—with specific guidance from the teacher during the playback process. Additionally, the student's performance can be

replayed repeatedly for reinforcement and even in slow-motion for detailed study, if the playback VCR or camcorder has slow-motion capability. Moreover, each taping session can be labeled and saved for replaying at later periods, so children can see the *progress* they made over time and benefit from the motivational boost of feeling successful at an endeavor.

Dramatizing Class Lessons

My son's school is very, very big on this. At the time I'm writing this, he's rehearsing his part for a class production called *The Constitution: Blueprint for a Nation.* He's playing Colorado—the entire state. The idea sounds a little weird, even to me, but I have to admit, I have a great deal of respect for his teacher for having managed to get to him *into Colorado* (his phrase, not mine).

Nonetheless, I would suggest that most teachers start out by using video as a means of having children dramatize lessons with a tad more pep, such as life in prehistoric times, ancient Rome, the discovery of America, the lives of historical figures, and so forth. Later, as both the teacher and students become more adept at employing video, I'd say it's time to try my son's teacher's approach and use video to instill some high-tech life to subjects usually considered dry, such as the U.S. Constitution.

The benefits of invigorating academic material through role-playing are significant, according to Irina Pigot, director of the East Manhattan School for Bright and Gifted Children, a New York private elementary school renowned for its use of performance as a learning tool. "Events of history, in particular, become more concrete for children when you give them an opportunity to *live* them," Pigot explained. "As distance is erased, history becomes more accessible, meaningful and interesting. Of course, the degree and quality of participation should depend on the age of the child. Older children can prepare their own material as well as design and make costumes for productions, while three- and four-year-olds can perform in roles in suitably simple ways."

By adding video to the process of role playing, students gain from the ability to assess their own performance, as well as from the highly valuable processes of planning and critiquing the production. Let's say you'd like your class to make a short movie version of a work of literature. The benefits of the planning process begin with a discussion of *which* book to dramatize. What do the students suggest, and why do they recommend certain books?

They should tell the stories in detail and try to explain their virtues. You could even go so far as to request that all the students in the class choose and read books they haven't read, or require that everyone read whatever book you finally choose. After the movie's finished, all the children should be encouraged to comment critically—and constructively, maybe in *another* videotape of a discussion group.

In general, no matter what type of movie students may make in the classroom, teachers should keep several main guidelines in mind:

Involve all the children, as you would in any class project. Don't let the natural thespians, the audio-video experts, and the attention-lovers in the class take over. Make the movie rewarding to all the students, by giving them specific and important tasks to perform, appropriate to their ages, skills and personalities.

Time your taping well. Video movie time will be an invaluable boost to the spirits of a class, so use it when you could use it most, such as Tuesday afternoon, Thursday morning, or during those gorgeous spring days when all the students are miserable about being stuck indoors.

Remember, video is just a starting point or touchstone for the students to explore the key subject areas you choose. Don't lose sight of the core lesson, be it a historical event, a work of literature, or current events. Stress planning, class discussions, homework, and written evaluations of the project, from beginning to end.

Be creative yourself. Since video is such a creative medium, use your own imagination to cook up ways to make the most of it with your class. What about starting a moviemaking contest? How about conducting your own class "Academy Awards"? Or initiating a video club? Put together an assembly and show your class's videos to the entire school. Invite parents, or circulate a copy of the finished tapes to the parents to watch at home. Tell the local newspaper what you're doing.

By giving your class video movies special attention and special effort, the projects will seem more and more special to your students and help them follow your lead and do the best *they* can.

For furthur study, some advanced video and filmmaking texts are available. My recommendations are *A Primer for Film-Making* by Kenneth H. Roberts

and Win Sharples, Jr. (Bobbs-Merrill), and *The Total Film-Maker* by Jerry Lewis (Random House and yes, it's *that* Jerry Lewis; he taught film-making at the University of Southern California for several years, and his lectures were compiled in a surprisingly good book).

V
SPECIAL STUFF

16

SPECIAL EFFECTS: LIVING–ROOM LIGHT AND MAGIC

A group of grade-school kids made a video movie a few years back and entered it in a national competition called "Visions of the USA." It won the top prize for its category, and one of the main reasons was a sequence that charmed the judges, including Francis Coppola, Jim Henson, Joan Lunden, Walter Williams (the creator of Mr. Bill) and myself. We had been huddled together in a screening room watching movie after movie all day, chugging coffee and arguing obdurately in politesse, when this short, modest movie cracked us up. In it, a cocksure kid was showing off, doing a workout routine. He made a big show of some standard exercises—first, conventional push-ups, then some push-ups with one hand. Then he did some with one finger, then some with *no hands*. He ended up floating above the ground unsupported, grinning a broad, wise-guy grin.

My esteemed fellow judges took on expressions of knowing delight, but I merely felt stupid delight. I had no idea how the 12-year-olds made the kid float. I had to ask Jim to explain it to me, and I learned not one but two basic lessons about special effects: One, a little bit of creativity can accomplish more than a lot of equipment or money; and two, the potency of an effect depends on the story set-up. The kids who made that movie had simply set up a wall to look like a floor, then shot with the camera turned on its side—

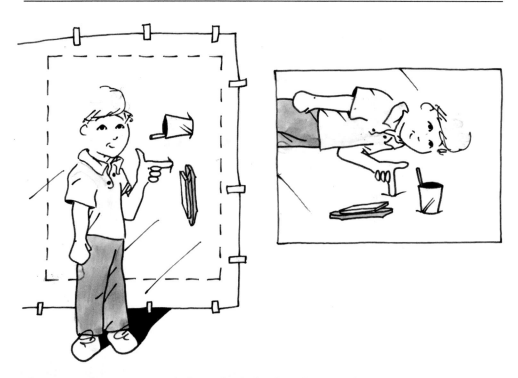

Shooting sideways: Here's how the kids shot that wonderful one-finger push-up sequence. The sketch on the left shows the real-life set-up, with objects taped onto the wall to make it look like a floor. The scene must be shot with the camera turned *sideways*, framed on the rectangular area indicated by the dotted line. In the second sketch on the right, showing what the shot would look like on the TV screen, the vertical plane appears horizontal and vice versa.

a twist on the rinky-dink shots of Batman scaling skyscrapers in the old TV series, in which he was obviously crawling across the floor with the camera sideways. The goofy trick worked so marvelously in the kids' movie because the viewer didn't expect it—surprise is always an essential element of illusion—while, at the same time, the effect fit in the context of the movie's story and style.

Cheap tricks can be great, especially on video. Even when they don't quite work, they're usually funny as heck to watch, and they're almost always a blast to shoot, anyway. Here's how to do some of the classics.

Sideways on the set: Jake and Joanne shoot the push-up sequence. Note that the paper plate and the cup—and the camera—are sideways.

Disappearing

This was the first special effect ever, pioneered by French illusionist Georges Melies in the 1890s. And a century later, the same dumb trick is still effective. Most home-moviemakers can already guess how to do it: mount the camera on a tripod or hold it down tight on top of a sound, stationary piece of furniture. Shoot your subject. Stop tape. Don't allow the camera to move a millimeter. Have your subject walk out of frame. Roll tape again. Poof—your subject has disappeared. To have a person reappear again, repeat the process: stop tape. Have the subject move back into frame. Roll.

Beyond its basic mechanics, this trick requires some finesse to come off well. For one thing, give the effect a rational context. Make your hero a Martian, the figment of someone's imagination, or an innocent who accidentally drinks a disappearing potion. Set up any situation in which disappearing makes sense, *but* do not telegraph the exact moment when the effect is due.

Remember that element of surprise. In fact, when the subject does disappear, try a bit of theatrical business to distract the viewer from the camera trick. Make an off-camera noise or have your subject clap hands to discourage viewers from noticing any glitches, camera movement, light changes or other potential technical flaws in the effect.

Anti-Gravity

To make objects float mysteriously upward into the air, here's another vintage trick. Fake out the viewer's visual equilibrium, as the 12-year-olds did with their no-hands push-ups. As always, start out by setting up a story in which the trick makes sense. (I don't want to keep repeating this point for every effect, so just remember it all the time, okay?) Then, establish the special-effect scene with a medium-long shot of your subject in a particular indoor environment. Normal objects such as plants or furniture should be around, but the background must be such that it would look virtually identical right-side-up or upside-down—for instance, a plain wall of any color, a brick or stone wall, a wood-panel wall. In the medium-long shot, the subject should pick up the object you want to float, which should be something that would fall downward fairly slowly or in an interesting fashion, such as a sheet of paper or an open bag of potato chips. Cut to a medium (waist-to-head) shot of the subject holding the object at his or her *side* in front of the plain background. Cut.

Now, this gets tricky. Reverse the side of your subject the camera sees. In other words, if you had seen the left side of the person and the object in the left hand, have the subject turn 180 degrees, so the right side and the right hand are now facing the camera. Also, switch the hand the object is in—say, from the left hand to the right. Then, have the subject turn the object upside down in his or her hand.

Carefully now, turn the camera *upside-down*. Shooting this way takes some getting used to, so take your time and make sure you can see clearly through the viewfinder and work the controls confidently. When you're ready, move in for a close-up of the hand. Roll tape. Let your subject drop the object, and follow it with the camera as it falls to the ground, cutting *before* you see any of the floor in the viewfinder. End of scene. When you replay the tape, the object will appear to float upward on its own power.

One pointer to help the illusion: For the opening shots, hang a picture directly behind the subject's hand. When you shoot the upside-down se-

quence, hang the picture upside-down also, to maintain continuity of perspective.

Rear Projection

Another special-effects pioneer, Willis O'Brien, made film history with this technique in the original *King Kong*. Today, variations of the rear-projection effect are used routinely in every production from feature movies to local newscasts, thanks to various techy processes such as the "ultramatte" and "chromakey." But who needs them? You can do some cheapo rear projection at home with video equipment.

Customarily, the rear-projection effect superimposes people in the foreground of previously shot footage, so they seem to be in the actual location of that footage. With home equipment, you can shoot someone standing in front of the TV screen with a broadcast or videotape playing behind them, but the effect will not be convincing, even if you zoom in so close on the screen that you don't get any of the TV chassis. Seen in direct comparison with a real person appearing in the same shot, the video image will not look realistic. Nonetheless, you can *use* that unrealistic look for certain imaginative types of movies. For instance, you can shoot someone carrying on a conversation with his or her own guardian angel or conscience—characters who, by their intrinsic nature, shouldn't be depicted realistically.

Let's do your son talking to his own conscience, a truly extraordinary occasion for most kids. Start out by writing out all the dialogue for both characters in the conversation. Then shoot your son saying only *his conscience's lines* as he watches someone off-camera mouth his lines, leaving silent space for his part to be added later. Frame the boy in extreme close-up in the left half of your viewfinder facing right, with a plain wall on the right side of the frame.

When you're finished, prepare to play the tape through a VCR (not through your camcorder; you're going to need it). Position your son directly in front of the TV, with his ears practically touching the screen. He should be in profile on the right half of the screen, facing left. Compose your shot very tightly, so you show only the TV screen area and none of the chassis. Start shooting, and play the tape you made earlier, with your son filling in his own lines to complete his conversation with his conscience. On the final tape, the kid should appear to be talking to a mystical image of himself. I've shot this myself with older kids, and it was as much fun to watch as it was nerve-racking to shoot.

Stop-Action Animation

Have a few days free to shoot a one-minute movie? Knock yourself out with the ultimate video pastime for compulsive personalities—the Gumby process. That is, the technique of making inanimate objects appear to move by maneuvering them in small increments while you turn the camera on and off. Everybody knows the idea; it's the essence of the motion-picture illusion, whereby rapid-fire sequences of individual still images trick the eye into perceiving movement. In live-action film, 24 different images are projected per second. In most animation today (whether based on drawings or real objects shot in stop-action), eight or 12 different images are used per second, projected at 24 frames per second with two or three identical images repeated in sequence to cut down costs. To produce a one-minute film by these means, you'd need to show 480 to 1,440 different images, depending on how natural you want the movements to appear.

At home, this is flatly impossible, because video cameras don't permit you to shoot one frame at a time. Still, many cameras can record several electronic "fields" in sequence for a workable approximation of stop-action animation. The resulting movements will be staccato but certainly acceptable, especially to young eyes. To shoot your own stop-action animation, start by planning the sequence meticulously. Don't forget: Reshooting ten seconds of material could take hours. As examples of potential projects, you could animate your kids' dolls or "action figures"; mold and manipulate your own characters out of clay; or create building-block structures that rise up and metamorphose without visible human help.

In our backyard, we once used a tiny toy flying saucer and my kids' space "figures," and made them look remarkably realistic with stop-action animation. The effect worked well because the inevitably herky-jerky movements of home-video animation look just fine when the things that seem to be moving are mechanical-looking characters such as space beings or robots. We were also careful to shoot *low* and *close*, so the toys looked as much like life-size objects as possible. (This process is called shooting "in miniature.") Most impressively, we cheated during the flying scenes. I simply threw the toy spaceship across the yard, and my brother shot it as it "flew." But I wouldn't recommend trying this with any breakable toy, unless you build the cost of a replacement into your movie's budget.

To animate the objects, mount your camera on a tripod, or clamp it securely to a piece of furniture. Set up the objects in their start-up position. Shoot the shortest sequence of footage possible with your equipment. Move each

It came from the toy chest: For stop-action animation, little objects can be a big hit when they're shot in close-up. The shot above is a frisbee-like gadget lying on a big rock. For the "flying" shot below, we simply threw the toy across the lawn and shot it while it was airborne.

object in one tiny increment—no more than half an inch. (The smaller the amount of space between shots, the more fluid, though slower, the apparent movement.) Shoot another instant of footage. Move each object again. And repeat this procedure again and again . . . you'd better have patience, or you shouldn't even attempt this. And keep on again and again, until you're finished or you have to clear the kitchen table for dinner.

A couple of tips: Don't use a window as a light source; as the sun moves, the brightness of your objects will shift and their shadows will move. Also, try a brief test of this technique, shooting a few seconds of footage and playing it back to evaluate how it looks before dedicating a whole day or more to such a demanding task.

Props

In movie magic, as in classical stage magic dating back to ancient China, props are as important as skill. Hollywood effects artists depend upon tools of the fake-out trade, such as artificial glass, synthetic skin, fold-in knives and blood capsules. And, though few home-video moviemakers realize it, anyone can create exactly the same props and effects at home using commonly available materials.

Artificial glass: On professional shoots, break-away bottles and panes of glass are made out of a sugar gel concoction that's difficult to mix and mold at home. Though it would melt under movie-set lights, *ice* looks even better, and it's easy to use in your home movies. To make a drinking glass out of ice, take two standard wax-paper cups, one slightly smaller than the other. Pour some tap water into the larger cup, then insert the smaller cup so there's a layer of water about a quarter-inch thick between the cups. Wrap a rubber band vertically around them (not too tightly, or you'll bend the cups), and freeze them overnight. The following day, tear the paper off and you'll have an extremely realistic-looking glass that's not glass, which you can use as a break-away prop in a Western saloon or other adventure scene. Keep in mind, though, that ice is almost as hard as glass; only break your ice glass over sturdy objects such as durable furniture, never over the bad guy's head.

Synthetic skin: Mix up some *clear* gelatin, following the directions on the package. Add ordinary make-up (foundation or other skin-tone formulations), until the mixture matches the color of your subject's skin. Let it thicken up to a gooey stage, but no further; if the mixture becomes too hard, you won't be able to mold it. Apply to the skin, and you can craft fake noses, double

chins, alien ears, warts and sores, all of which peel off painlessly and look beautifully disgusting.

Novelties: In most of the major toy stores such as Toys R Us and Child World, the novelty sections are little-known resources for dozens of useful props for home movies. Ask any 11-year-old boy. He'll tell you the best place in town to find fold-in knives, fake-blood capsules, ecchy rubber bugs and snakes, fangs, fright wigs and a variety of monster make-up kits. They're inexpensive, too, carefully priced to match a standard week's lawn-moving wages.

Editing Effects

Some of the easiest and most convincing movie tricks of all, editing effects exploit the motion-picture medium's manipulation of time. There are three major types of effects in this category: creative cutting, switched sequence and false context; and I'm going to put them all in one hypothetical movie. (To perform the final two effects, two VCRs are necessary. See Chapter 17 for further details on editing.)

A four-foot-six, eight-year-old girl will now perform the greatest basketball shots in sports history, to graciously demonstrate creative cutting. In a typical driveway basketball court, shoot the girl fooling around casually with the ball. Enter her big brother, who blindfolds her and walks her all the way across the yard to a spot about 100 feet from the basketball net, and turns her in the direction of the house. She drops the ball, as if to kick it. Cut.

Take off the blindfold. Move in for a close-up of her feet, roll tape, and let her kick the ball. Don't follow it with the camera. Cut. Big brother throws the ball toward the roof of the house. Shoot it in flight after it leaves his hands, without showing him in the shot. The instant the ball hits the roof, cut. Have brother throw the ball so it starts to roll horizontally across the roof. Shoot it as it's rolling, cutting before the roll slopes downward notice-ably. Move over to the net. Have brother toss the ball up on the roof so it drops down toward the direction of the net, and shoot the movement of the ball. Cut. Brother tosses the ball in the net with a high arc, and shoot it plopping in. Cut.

Obviously, every one of those shots won't come out perfectly on the first try. So keep shooting until you're happy with each take, replaying the whole sequence in your camera's electronic viewfinder as you go along, to monitor

your progress on the spot. In the end, it should look pretty funny, albeit ludicrously unconvincing.

The following shot, an example of the switched-sequence effect, will look much more realistic. This time, pull back for a long shot and let sister throw the ball with all her might in the direction of the sidewalk. Follow the ball continuously, wherever it goes, zooming in on it when it finally stops, wherever it stops. Let's say, for our purposes, the ball rose about five feet, bounced seven times, ricocheted off a fire hydrant, fell into the gutter and rolled 20 feet till it stopped under the back tire of your neighbor's car. Cut. Slip a penny under the ball. Have sister go over to the ball and shoot her removing the ball and uncovering the penny. Cut.

Now for the sly part. Shoot sister next to your neighbor's car, saying dialogue like this: "I shall now perform an absolutely incredible trick. Notice the penny I am putting under this tire. Now, I shall walk over to the middle of our yard, and I shall throw this basketball into the air with incredible precision. It will then rise five feet, bounce exactly seven times, ricochet off that fire hydrant, fall into this gutter and roll precisely 20 feet till it stops under the back tire of the car, directly on top of this penny. Watch!" Cut.

Get it? Simply change the order of the sequences in the editing process so the girl seems to be predicting her shot in advance rather than describing it after the fact, and I promise your audience will be confounded.

If not, try this, the false context effect: Stand sister ten feet from the basketball, blindfolded, facing in the wrong direction, and have her throw the ball up to the net. Naturally, she'll miss. It would probably take her 200 tries to make a shot like that. So, mount the camera on a tripod, switch it on to AC and plug it into a long extension cord leading into the house, drop in a six-hour tape, and let her try the shot 200 times. I know: she probably won't want to spend all day throwing basketballs backwards. *But*, if she did, and if she ever did make the shot, you could edit out the other five hours and 59 minutes of footage and have one heck of a piece of footage. Nobody would ever figure out how you did that one.

17

EDITING:
CUTTING REMARKS

The "last rites" of the motion-picture faith, editing represents the final opportunity for professional producers to mend the wrongs of errant scriptwriters, performers, directors and other creative personnel before a movie faces reckoning in the omnipotent marketplace. On the editing table, bad footage can be cut, new material inserted, voices replaced, music added, and much more done in acts of film salvation. Big-time movie editing is almost miraculous sometimes—and, though many people don't realize it, video movies can be edited at home, too. But I don't like the idea, and I don't recommend home editing, as a rule. It's a crutch. When you have the notion in the back of your mind that your footage will be edited at a later point, your shooting tends to get sloppy; you don't plan as thoroughly, don't shoot as discriminatingly, as you would when you know you've only got one chance to do things right. If there's no suffering, you sin.

Even if you're determined to edit after you shoot, you may never get around to it. The inertia of a project abates after you've finished shooting all your footage and shown it a few times. By then, you often don't feel like going through the trouble of editing just to fix a few boring or technically shoddy scenes. You live with your mistakes. Yet, you might never have made those mistakes to begin with, had you been more careful during the shoot.

This is not to negate the value of editing as a means of refining movies and expanding the available creative options, especially for those moviemakers with skills and ambitions more advanced than those of most camera owners. If you have the orientation for electronic editing as well as the time for it, home editing can help polish your products with improved pacing, sound and visual effects.

In addition to the proper orientation and time, video editing requires some equipment—at the minimum, two VCRs (or one VCR and one camcorder with playback capability). Of these two machines, one will function as the "source" deck, playing your original footage. The other will serve as the record deck, re-recording that footage onto a new cassette. Naturally, the two decks need to be hooked up, wired from the audio and video phono plugs marked "out" on the source deck to the audio and video "in" plugs on the record deck. The "out" plugs on the record deck should lead to a monitor or TV set, so you can see what you're doing when you're editing. To edit, play your original tape through the source deck and re-record it on the record deck—stopping (with the *pause* control of the *record* deck) when footage appears on the monitor which you want to delete; then, starting up again (obviously, through the record deck) when footage appears which you want to include. Using this basic technique, you can change source tapes and include snippets from as many different tapes in your collection as you like, provided they will fit on the cassette in your record deck (and provided they aren't store-bought prerecorded tapes, which are illegal to copy in whole or in part).

A few tips:

- If, while you're recording, you use any of the playback "effects" of the source deck such as freeze-frame, slow-motion or scan, the resulting image of those effects in use will be transferred onto the record-deck cassette. Consequently, when you watch that tape in the regular "play" mode, those effects will appear. Pretty neat, huh? This means you can freeze the characters in your movie whenever you like for a snazzy sci-fi look, or speed them up for Keystone Kops-style sequences.
- Since you're making a tape of a tape, you will inevitably find a visible degradation in picture quality (called generational loss). The only way to try compensating for this is to buy or borrow a "signal enhancer" (a small component available in specialty stores for a couple hundred dollars or so) and hook it up between the source and record decks.

- Don't forget *sound* when you're editing. Listen while you're watching, to avoid cutting in the midst of conversations and other important sounds. Try to cut only during "dead" audio. Remember, too, that a new audio track can always be added to any tape (whether or not you go through the process of editing) by using the "audio dub" feature on virtually every VCR. With it, you can add music or new dialogue (recorded with a microphone hooked up to the VCR's audio plug) at any point you want, although the new track erases the original track (including the original dialogue).
- Still photos, other artwork, text, slides and *film* movies can also be edited into your projects, after you've had them transferred to videotape. This transfer can be done through most photo labs and some tape-rental stores, It's not outlandishly expensive unless you request complicated work involving a lot of still artwork. Alternatively, you can transfer all kinds of material onto video with your own camera, by use of a transfer kit available at photo shops.

On the subject of accessory products, some remarkable equipment is available today for performing studio-type editing tricks such as fade-outs, fade-ins, "dissolves," "wipes," color effects, pixilation, and much more. The products cost anything from a few hundred to several thousand dollars depending on their capabilities and quality, and they're sold by electronics specialty stores and through mail offers advertised in the video, photography and electronics hobby magazines.

VI

A LITTLE TECH

18

ACCESSORIES:
LENSES, LIGHTS,
AND MICROPHONES

In electronics and apparel, accessories do the same thing. Snap on a starburst filter. Toss on a silk scarf. Plug in a soft spotlight. Flip on a baseball cap. That extra touch adds an accent to your primary material and refines the message you're trying to communicate. With a filter's twinkles of light or a spotlight's glow, an ordinary scene becomes either glitzy or ethereal, just as a silk scarf or a baseball cap shows that you're either sophisticated or earthy—or that you want people to think you are, or that your head's cold. Accessories are not a precise science in moviemaking or wardrobe.

Still, the most popular home movie accessories—lenses, lights and microphones—perform certain clearcut technical functions with sufficiently predictable perceptual results. Here are some examples for using the most accessible accessories for making movies with the family.

Lenses and Filters

Hemispheric Lens

Increases the image area (or hemisphere) your camera can capture in one shot, usually by two or three times. Also increases depth of field, so all objects

in the viewfinder from a distance of a few feet to infinity will be in focus at the same time. Good for getting large groups in one scene, but makes everything look much smaller, compressed. Best choice for shooting a Weight Watchers meeting.

Macro Lens

Allows you to focus on anything within inches of your lens, which is otherwise impossible unless your camera has a built-in macro control. Nice for detail close-ups of the kids' craft projects or artwork as well as shmaltzy nature photography. Because of its shallow depth of field, it knocks distant objects out of focus.

Wide-Angle/Fisheye Lens

Extreme version of a hemispheric lens, pulling virtually everything in the human eye's field of view into one shot. The fisheye's radical twisting of perspective is fairly tolerable in long shots, although it exaggerates facial features up close, making everyone look like Barbra Streisand.

Telephoto Lens

Magnifies subjects like a telescope, typically by a factor of one to 1.5. Practically a necessity for shooting sports from stadium seats and other long-distance efforts. Bulky and sometimes heavy and awkward to hold. But extremely useful as well as very impressive and macho to use in front of your less-equipped friends.

Fogalizing Filter

Not especially important, but I really like to use the word "fogalizing." It's that effect when the outer edges are all blurry and the center of the screen is in focus. Effective but corny for fantasy sequences and portraits; who shoots portraits on video, though?

Multi-Image/Prism Filter

Produces several identical images of a subject, which you can rotate around the center image. Will bring back mom and dad's psychedelic days, and kids love it, too.

Neutral Density Filter

Maintains a bright, clear center image while darkening everything surrounding it. Looks old-fashioned, like the way the ingenue was shot in silent

The Barbra Streisand Effect: With an ordinary lens, Megan *looks* ordinary (top). Adding a wide-angle lens radically distorts her features (bottom).

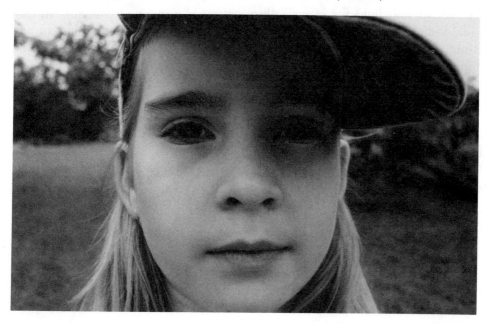

movies. Valuable when used judiciously, however, such as to downplay unwanted background material.

Starburst Filter

Turns any and every point of light into a bright, sparkling star. Transforms your living room into Caesar's Palace. Okay for a short, atmospheric sequence of very special material, such as Christmas-holiday events or when Suzanne Somers comes over to your house.

A note on video lens configurations: Different makes and models of cameras and camcorders produced over the years have various lens sizes and designs. Some are removable and some stationary. Some of the removable lenses are screw-mounted and some C-mounted (push in and turn). Before you spend money on any lens or filter, make sure it will fit; your equipment might require the use of an adapter ring to affix certain lens accessories. To be safe, always shop with your camera on hand, resisting mail-order purchases unless you're sure you know exactly what you're doing.

Lights

Floodlight

Powerful, soft light for overall illumination of a scene. Invaluable in dim available-light situations and also good for adding highlight strokes in any setting, when positioned at aesthetic angles and distances. Can usually be clipped onto furniture, mounted onto a tripod or handheld.

Spotlight

Intense, directed source for lighting finite portions of a shot such as individuals in dramatic or musical performances. Usually variable for a range of coverage options from small "pin spot" to a wide "police light." Theatrical, almost metaphysical in its power to transfigure family members into showy personalities like Sammy Davis, Jr.

Mini Portable Light

For general-purpose illumination, sometimes adjustable to serve as either flood or spotlight. An important asset for vacation movies, when you might be visiting someplace special for a brief period and it's too dark for videotaping. Typically, can be connected to the light shoe on top of the camera.

A note on lights and power: Like all electronic devices, video lights require

their own power sources; they cannot run on cameras' built-in batteries. Indoors, an AC-powered video light may be plugged into a wall socket for easy and economic operation. Outdoors, however, a light requires a DC power source such as a car cigarette-lighter adapter or a battery pack.

Batteries are boring. But if you're ambitious enough to be interested in using outdoor video lights, you should have a handle on the rudiments of battery technology. In a nutshell, video moviemakers can choose from two main types of batteries: lead acid or nickel cadmium (NiCad), each of which has advantages and drawbacks. The lead acid type is less expensive and holds its charge longer when not in use, but it's heavier and wears out after a few years or so, depending on how heavily it's used. The NiCad variety is lighter, holds far more power per pound, and can be recharged literally thousands of times, but it's more expensive. Regardless of type, all batteries and portable power packs are available in an enormous range of sizes, power levels and prices. So choosing one clearly requires comparison shopping and thorough consideration of your particular needs, physical strength, and budget.

Microphones

Boom Mike

As I've discussed in detail earlier, a boom mike (or a wireless mike; see below) is all but essential for many types of home moviemaking. With a boom attached to your camera's light shoe, you direct your recording of sounds as you do images, capturing only what's emanating from the subjects at which you're aiming. The virtues of this approach are immeasurable when you want to hear one particular person, especially outdoors where ambient sounds are as unpredictable as the kids.

Handheld Mike

This is a professional-looking hand microphone, ready for spinning around by the cord and breaking the first day. I wouldn't recommend buying one, though it would certainly look cool in home-movie versions of TV and stage shows . . . For the same cost, you'd get a whole lot more use out of a boom or wireless mike (below).

Wireless Mike

As I've repeated throughout this book, a wireless mike (like a boom) can be a precious aid in the clear and effective telling of movie stories. Half of

the device, a gumball-size mike attached to a pocket transmitter, clips onto your subject's clothing. The other half, a receiver, goes on top of your camera. Together, the set-up ensures that you record the voice you want vividly, no matter what kind of racket's going on around you.

19

TAKING CARE: MAINTAINING YOUR MOVIE EQUIPMENT

Video cameras are too much like people, in a way. Regardless of how tough they may appear on the surface, they're sometimes surprisingly sensitive on the inside. One week they may be going strong, and the next week they may fall completely apart.

Why? And what can parents do to keep home movie equipment working well? There are several essential guidelines for the maintenance of every type of video camera, camcorder and VCR product, regardless of its configuration, brand or model. Whatever camera you may use, it's susceptible to the two main kinds of maintenance problems: contamination and the elements.

Contamination

It's important to remember that video moviemaking, like every type of tape recording, involves *two* machines. One is the camcorder, obviously, and the other is the video cassette—a tiny machine in itself, composed of precision-calibrated guide wheels, spools and other moving parts in addition to hundreds of feet of tape. When these two machines are working well together,

you get clear, strong pictures and sound, with minimum deterioration of the camcorder or the cassette. Occasionally, however, a tape will generate fuzzy or distorted images and warbled, muffled or distorted sound. Other times, a camcorder or VCR will "eat" or even shred tape for no clear reason.

The unclear reasons for these problems are system contamination—introduction of destructive foreign substances such as accumulated dirt, dust, hair, body oils, and loose particles of the tape oxide (the dark-brown material on the surface of tapes, which contains the picture and sound information in magnetic form). Most of the microscopic garbage in the atmosphere happens to be invisible to the naked eye, yet it frequently settles into the tiny openings and crevices in a camcorder's casing. "I've seen traces of almost everything imaginable inside video equipment," Bob DiMaggio of Panasonic's national service headquarters told me. "Kids put peanut butter sandwiches inside the tape slots. They think they're slot machines."

Should a child (or an adult) touch the actual tape inside the cassette housing, the worst is conceivable. Once tape slips out of its protective casing, any wrinkles or creases could easily scratch or chip the camcorder or VCR head beyond repair, requiring replacement—usually at a cost greater than that of a new VCR.

To protect video equipment from every kind of contaminant, first, always keep it closed up; never leave a camcorder lying about with its tape-eject door open. And, second, simply keep it clean. When it's not in use, always keep it in a protective case or a closet. And, last, never let the kids get near the equipment with dirty hands, let alone food.

The Elements

Heat can cause significant problems for video equipment if you keep it directly in front of a window or take it outside under the sun for too long. Not even portable gadgets such as cameras are designed to take exposure to the scalding summer sun for hours at a time. Soon, the lubricants essential to a camcorder's moving parts may gum up, or circuitry may literally burn out and require major repairs.

In wet or damp environments such as the beach or muggy days, humidity can clog moving parts, just as it can make human parts start to feel stiff. Regrettably, there isn't much you can do about the problem other than protect your equipment from direct exposure to water, waves and rain.

As the best aid in regular maintenance of a camcorder, to help clear up

the problems of both contamination and the elements, use a quality *head-cleaning cassette* every few months. But make sure to use only the *wet, nonabrasive* type of cleaning cassette. Otherwise, the cumulative mess inside a camcorder or VCR may eventually become so bad that home head-cleaning can't do the whole job. Then, an interior clean-up by a professional servicer would be necessary, at a cost anywhere between $50 and the cost of a brand-new camcorder.

20

FILLING IN THE BLANKS:
SOME TIPS ON TAPE

The only major element of video movie production I haven't yet discussed is the tape. And that, believe it or not and despite whatever else you might hear from salespeople or advertisements, is simply because there isn't a whole lot to say that's of significant value to most parents. The truth is, the vast majority of tapes on the market today are capable of outperforming the cameras and VCRs in which they're intended to be used. That's not at all my personal opinion, by the way; that's the published conclusion of every test report on blank video cassettes I've seen over the past 10 years. In other words, most families can use most of the more than 150 types of tape available from more than 30 companies with fine results, so long as the tape is in the same format (Beta, 8-mm or VHS) as the camcorder, of course.

Naturally, tape quality does vary from brand to brand and from "grade" to "grade" of cassette, just as all products vary. However, the details of determining the degrees of tape-quality variance and their relative value to video buffs are certainly subjects a bit too arcane for discussion here.

There is one critical area of exception, however, as well as another aspect of tape with whic' all home moviemakers should be familiar. The area of exception involves unlicensed cassettes, and the other aspect of tape pertains to the slew of cryptic trade names under which tapes are being sold today.

In order to ensure that cassettes will work up to snuff in the equipment they manufacture, camcorder and VCR companies require that all cassettes be labelled as legally licensed products in each of the basic video formats—Beta, 8-mm and VHS. Only licensed cassettes are permitted to carry the *logos* of these formats on their packaging. Therefore, it is absolutely essential that conscientious home moviemakers make sure to look for those logos every time they shop for tape. If a cassette does not specifically include the logos, and instead says "B," "V-type," "VH" (without the "S") or other vague jargon, *do not* buy it. You could easily ruin your home movie, or even your video equipment.

How? Among other problems, substandard tape tends to shed its magnetic particles while it's being used. When those particles clog up the recording and playback head inside a camcorder or VCR, picture quality becomes degraded, sometimes horribly. In worst instances, shedding can even damage a camcorder head beyond repair, in which case it could cost nearly as much to replace the head as it would to buy a brand-new camcorder.

Tale of the tape: Only licensed, name-brand cassettes such as this are likely to meet established standards for performance and construction.

Frank Barr, President of the Advanced Product Evaluation Laboratories that conducts tape tests for *Video Review*, told me he's seen equipment severely damaged by unlicensed cassettes. "If the tape is poorly made, its coating is soft, and the heads will more or less dig right into the coating. When I test the cheaper tapes, it's not unusual to find shedding." In one case, Barr played an oddball brand of blank tape only six times, and he found so much shedding that it destroyed the heads of one of his laboratory's VCRs. "No matter what we did, we couldn't get the [shedding] out," he says. "I had to go out and buy a new head for the recorder."

My second warning on the subject of tape also involves the wording of packages, although it pertains to licensed as well as unlicensed cassettes. Both are sometimes guilty of the same marketing misdemeanor. They have jargon on their products that is enormously misleading, although not quite inaccurate, such as "color," "stereo," "hi-fi."

All of these phrases are virtually meaningless in video, because literally *all* and *none* of the blank tapes in the world are color, stereo, or hi-fi. In video, unlike film, it's the equipment involved that determines factors such as color, stereo or hi-fi capability. A color camera will record color movies on *any* tape. Similarly, whether a movie can be videotaped with mono or stereo sound is 100 percent a function of the recording equipment, not of the type of tape being used. This unalterable fact makes every single brand of videotape in the stores both mono and stereo, just as every one is color and black-and-white.

VII

READY-TO-SHOOT SCRIPTS AND STORY IDEAS

21

THE INVISIBLE KID

Idea:
A science-fiction adventure/comedy with some simple special effects.

Cast:
 The Invisible Kid (who is not invisible at first)
 His Mother (or father or big brother or sister)
 His Best Friend (or relative, as long as the person is different from the character above)
 His Pals (any number)
Note: This movie can be made with almost any group of kids and adults—as few as three, as many as a dozen or more.

Crew:
One camera operator; one special-effects director.

Production Notes and Pointers:
 (1) Of all the classic visual effects, invisibility is certainly the cheapest. This movie requires no special equipment or expertise. The only props necessary are a clear drinking glass, two cans (not bottles) of grape soda; an actual grape; and a blanket, sheet or drape.

(2) Though it's cheap, invisibility isn't so easy to portray well. Your actors need to perform pantomime convincingly, and that involves some practice. Make sure to rehearse this project like a stage play before you roll tape.

Shooting Script:

SHOT: The Invisible Kid and His Best Friend are sitting on the floor talking or playing (a game or with toys), facing each other. The Invisible Kid is drinking grape soda from a clear glass. A few other kids might be visible in the room, talking and laughing quietly. If you have some empty cans of grape soda, pile up as many as possible next to The Invisible Kid and His Best Friend.

> HIS MOTHER
>
> Look at you! How many times have I told you not to drink so much grape soda? Now, I don't want you taking one more sip of that stuff. Okay?

> THE INVISIBLE KID
>
> Okay, okay—I promise.
> (He hands her his glass, and she walks out of frame. As soon as she's gone, he pulls a hidden can out from behind his back and starts drinking.)

> HIS MOTHER
> (from off-camera)
>
> I saw that—and you *promised*! From now on, all you're allowed to drink is *this*!
> (She walks in and hands him a tall, clear glass of water.)

> THE INVISIBLE KID
>
> What is this stuff? It looks . . . *invisible*.

> HIS MOTHER
>
> It's called "water," and that's all you're going to be drinking from now on. If you have any more grape soda, you're going to turn into a grape.

> THE INVISIBLE KID
> (examining the glass incredulously)
>
> Well, if I drink *this* stuff, it'll turn me invisible.

(The joke makes the other kids laugh, and The Invisible Kid goes along with it by making funny grimacing expressions while he guzzles the whole glass of water.)

SHOT: Close-up of his hand as he plops the empty glass down, still holding onto it. Make sure he's wearing a long-sleeved shirt. And remember the exact way you compose this shot, for future reference.

SHOT: The Invisible Kid, in close-up.

THE INVISIBLE KID

Who knows what this stuff can do to you? I don't know any other kid who ever drank a glass of plain water.

SHOT: His Best Friend, in close-up. At first, he's laughing at The Invisible Kid's comment. But, as he lowers his head, he stops cold.

HIS BEST FRIEND

Oh my gosh! Look at your hand!

SHOT: Remember that close-up of The Invisible Kid holding the empty glass? Duplicate it, with the glass and The Invisible Kid's arm in exactly the same place—*but* have The Kid curl his hand up into his sleeve, so it looks as if his hand is missing. During this shot, have the Invisible Kid say the following from off-camera:

THE INVISIBLE KID

Uh-oh. No hands.

SHOT: His Best Friend, in close-up.

HIS BEST FRIEND

Ho . . . ly . . . heck!

SHOT: Before you start this shot, have The Invisible Kid take off his shirt. Put it on a different kid, with the collar pulled all the way up over his head. Keep the buttons by his mouth open, so he can breath perfectly. Stuff some towels on top of the kid's shoulders to help make the shirt look as natural as possible, but don't take too much time aiming for perfection; it's not necessary. Crop in for a close-up of the space where the head should be. Don't show a lot of the shirt. Most important, keep this shot very brief—only about a second, so the viewer won't have the time to look very close. During the shot, have The Invisible Kid speak into the mike from off-camera in a clear voice:

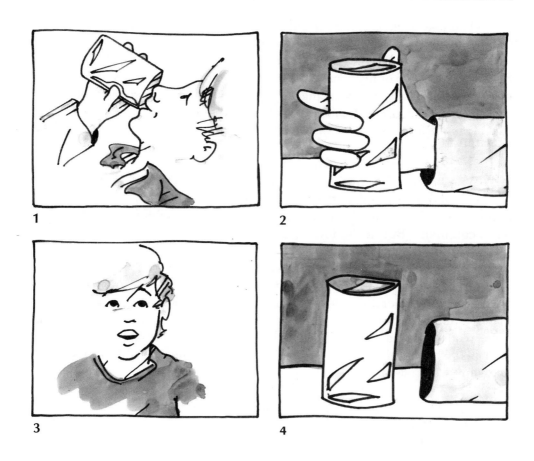

What you don't see is what you get: A shot-by-shot guide to shooting *The Invisible Kid* in storyboard form.

5

6

7

8

THE INVISIBLE KID

Uh-oh. No head.

SHOT: His Best Friend, shot head-on in full body. He rises up to his feet. As he does, someone alongside the camera operator starts tossing all The Invisible Kid's clothes toward His Friend, so it looks as if The Kid is disrobing off-camera. If there are other kids in the room, they should start gathering behind His Best Friend, oohing, aahing and pointing toward the camera, where the Invisible Kid is supposed to be.

HIS BEST FRIEND

Wow!

THE INVISIBLE KID
(his voice, as each piece of clothing is tossed)

No arms . . . no body . . . no legs . . .

SHOT: Reverse the perspective of the last shot, so the camera is looking straight at the area where The Invisible Kid should be. Actually, he is off-camera speaking into the camera's built-in mike. This shot of a voice and no body creates the impression that The Kid has completely disappeared.

THE INVISIBLE KID

. . . no feet . . . no me! This is great!

SHOT: The whole room, with all the kids gathered in a semicircle around the spot where The Invisible Kid seems to be.

HIS BEST FRIEND

What does it feel like? How are you?
(No answer)

ONE OF HIS PALS

Where are you?

THE INVISIBLE KID

(laughing, taunting them) Try to find me! You can't find me! (Pandemonium erupts. The kids scatter noisily, hollering cat-calls, scurrying around the room, waving their arms in the air to try to find him. Meanwhile, his laughter and taunts continue; do this by having him speak into the camera from out of frame.)

SHOT: The door to the room closes by itself. To create this illusion, have someone lie on the ground and slowly move the door while you aim the camera above the person's body. Make sure the door closes very slowly.
SHOT: His Pals.

<div align="center">ONE OF HIS PALS</div>

He left! Let's go get him.

<div align="center">HIS BEST FRIEND</div>

All right. Here's the plan.
(The Pals watch attentively as His Best Friend reaches into a nearby closet and pulls out a large blanket.)

<div align="center">HIS BEST FRIEND</div>

We spread out around the house. And when one of us finds him, he calls the rest of us. And we all jump him. Then we wrap this blanket around him. Ready?

<div align="center">ONE OF HIS PALS</div>

Yeah—let's go get the *jerk*!
SHOT: Close-up of the Pal who just called The Invisible Kid a jerk. He pretends he's being socked in the jaw at the same instant someone punches the palm of his or her hand next to the camera's mike.

<div align="center">ONE OF HIS PALS</div>

Owww! He hit me! He must have closed the door from the *inside*.
SHOT: All of His Pals, in a medium shot of the room. The kids start looking around for him again. He bursts out laughing—which, again, is done by having him laugh off-camera. When His Best Friend hears the laugh, he acts as if he locates him, lifts up the blanket and starts to throw it around him. Cut in the middle of the throw.
SHOT: The Pal who got punched in the jaw, in close-up.

<div align="center">ONE OF HIS PALS</div>

Way to go!
SHOT: Before starting this shot, bring out the real Invisible Kid and have the other kids cover him up with the blanket. Make certain his feet aren't showing and light isn't shining through the blanket and revealing any of his body or clothes. Roll tape as the kids huddle around the blanket with The Invisible Kid squirming inside.

THE INVISIBLE KID

Let me out of here!

HIS BEST FRIEND

Quick—somebody grab his feet. And somebody grab each one of
his arms.
SHOT: Four kids move behind and underneath the blanket in position to
hold The Invisible Kid by his arms and legs. With the real Kid still in there,
His Best Friend lifts the blanket and holds it straight up in the air, covering
the Kid from the camera's view.
SHOT: Close-up of His Best Friend.

HIS BEST FRIEND

Do you have him tight?
SHOT: Before this shot, have The Invisible Kid move out of camera range
again. Keep the other kids in their same positions, with His Best Friend still
holding up the blanket. Start shooting. His Best Friend drops the blanket
and the four kids should pantomime a struggle with The Invisible Kid to
keep him in place. At the same time, The Kid is speaking into the mike, off-
camera.

THE INVISIBLE KID

Cut it out! Let go of me, will you?
(During the struggle, His Best Friend goes into the next room and
quickly comes back with a can of grape soda.)
SHOT: Close-up of His Best Friend opening the can. The purpose of this
shot is to show that the can is new and full, not a special prop. Cut. Then,
with the camera off, pour the soda out so the can is empty.

HIS BEST FRIEND

Open up . . .
SHOT: As the kids continue to pantomime a struggle with The Invisible
Kid, His Best Friend pretends to pry his mouth open and pour the "full"
can of soda down his throat. To make this work best, pour some soda into a
glass next to the camera's mike for the appropriate sound effect.
SHOT: His Best Friend in medium close-up.

HIS BEST FRIEND

That ought to do it.

SHOT: Before this shot, place one actual grape on the floor where The Invisible Kid was supposed to be standing. When you start shooting, show the whole gang. They've stopped struggling, but the grape soda hasn't made The Invisible Kid reappear. Shocked, the kids are suddenly staring down at the ground. His Best Friend leans down and picks up the grape from the ground. Zoom in to a close-up of the grape in the palm of His Best Friend's hand. (This time, The Invisible Kid finally did turn into a grape.)

HIS BEST FRIEND

Oh no . . .
(Fade to black)

22

THE HOMEWRECKING GAME

Idea:

A game show that tests parents' and kids' knowledge of each other. At least two teams play, with each team composed of one parent and one kid. The parents must answer questions about their teammates while the kids are out of the room; when the kids return, they must answer questions about their parent, who is then out of the room.

Cast:

Five or more—a host plus at least two teams of two players apiece. The kids can be of any age past four. (In this sample script, I've named the players Mom, Dad, Ted and Alice, though your kids don't need to have those names in order to play.)

Crew:

None. The players in the game do all the camera work. Set them up on a sofa or in a row of chairs, and position the host in a seat facing them from six to ten feet away. When the players are on camera, the host does the shooting. When the host is on camera, one of the contestants does the shooting. No matter who is talking, a video camera's built-in mike should always pick up everybody's voice.

Production Notes and Pointers:

(1) Keep the shots simple, so as to concentrate on the answers and reactions of the players. Frame a person's face nicely, and keep your itchy fingers off the zoom.

(2) The host in this game has to be part pace-setter, part referee, part instigator, part shrink. It's the host's responsibility to keep the action moving, avoiding uncomfortable silences with pointed follow-up questions and repartee that get the players going, preferably into interesting emotional territory.

Here's an example:

Mom (answering a question): I punished him because he came home late.

Host (ad-libbing, to Ted): Where were you last night?

Ted: In the library.

Host: Mom, do you believe that?

The idea is to make seemingly innocent, innocuous comments that are actually probing personal questions.

(3) Somebody had better keep score, either in his or her head or on paper.

Shooting Script:

SHOT: Close-up of a plain surface such as a wall or a door. During the introductory dialogue below, zoom back to show the host either walking through the door or stepping in front of the wall from off-camera. The host should then sit down in a seat facing the camera, smiling ingratiatingly.

VOICE
(of one of the players)

It's time to play . . . *The Homewrecking Game*—the game *you* play in *your* home, until you wreck it. And here's the star of our alleged show . . . [add the name of your host here]!"

(Everyone off-camera applauds wildly)

SHOT: Host, in close-up.

HOST

Thank you. Thank you. And welcome to *The Homewrecking Game.* The object of our game is to find out how much we truly know about the people we love, and to see if we can find out without bludgeoning each other. Now, let's meet our teams for today.

SHOT: The contestants. Start out with an overall shot of the group. Then close in on the first person on the left (Mom). As each player is introduced with the following dialogue, pan across to the appropriate person's face and stay on it until the next person is announced.

<div align="center">HOST</div>

Here's Mom . . . her partner and daughter, Alice . . . Dad . . . and his partner and son, Ted.

(Note: Everyone should feel free to respond naturally, with comments such as "Hiya, happy to be here," "Buzz off" or whatever.)

SHOT: Host.

<div align="center">HOST</div>

To start the game, I'd like to ask the adults to leave us temporarily while we ask the kids some questions about their folks.

(Note: Mom and Dad get up and leave, staying somewhere off-camera and out of earshot until they're called back into the show.) Kids, for five points, tell me: The last time Mom or Dad got really mad at you, what was the reason?

SHOT: Alice.

<div align="center">ALICE</div>

[Her answer]

<div align="center">HOST</div>

Okay. Now, Ted, the same question for you.

SHOT: Pan over to Ted.

<div align="center">TED</div>

[His answer]

SHOT: Host.

<div align="center">HOST</div>

Next question. Kids, for five points, tell me: How much money do Mom and Dad make in one year?

SHOT: Alice.

<div align="center">ALICE</div>

[Her answer]

SHOT: Ted.

<div align="center">TED</div>

[His answer]

SHOT: Host.

HOST

Here's the last question of this round, for ten points. Fill in the blank, Alice: "It really makes me laugh when I see my Mom *blank*."
SHOT: Alice.

ALICE

[Her answer]
SHOT: Host.

HOST

Now Ted, your turn. Fill in the blank: "It really makes me laugh when I see my Dad *blank*."
SHOT: Ted.

TED

[His answer]
SHOT: Host. Before the camera starts, the adults come back and take their seats next to their partners.

HOST

Thank you, kids. Now, we've asked the adults to come back and see if they know as much as their partners *think* they know about *them*, whatever that means. The first question we asked was this: "Kids, the last time Mom or Dad got really mad at you, what was the reason?" Mom, how do you think Alice answered that?
SHOT: Mom and Alice. Whenever both partners are together, show them in the same frame in order to catch all their reactions to each other's comments.

MOM

[Her answer]

That's the format. You'll be able to take it from here on your own. After the adults answer what they think the kids said, reverse the whole process and pose questions to the parents while the kids are out of the room. Here are the three questions for the adults:

(1) What is your partner wearing right now?

(2) Name your partner's favorite rock star.

(3) If your partner could have anybody else for a parent—a famous person, a friend or another member of your family—who would it be?

Additional Questions

For the kids:

How old are your parents?

What are your parents' middle names?

What did you have for dinner last night?

Name two presents you received for your last birthday.

Parents make mistakes and do bad things, just like kids. What's one bad thing your parents have done?

What's the greatest thing your parents have ever done?

Which one of mom and dad's friends do you like best?

When mom and dad argue with each other, what are they usually arguing about?

If your dad were a famous character, which of the following would he be: Superman, Oscar the Grouch, Road Runner, Goofy.

Name one thing your parents like which you can't stand. It could be a TV show, a singer or band, a type of food, a restaurant, or anything else you can think of.

For the parents:

Name two children—first and last names—from your partner's class in school.

What is one thing—such as a toy, a piece of sports equipment or clothing—your partner doesn't have which he or she wants very badly?

What's your partner's favorite food?

Name the last book your child read.

What does your partner want to be when he or she grows up?

What would *you* like your partner to be when he or she grows up?

You're talking to your partner. Fill in the blank. "If I've told you once, I've told you a thousand times. I don't ever want to see you _____ again!"

On what occasion did you feel the most proud of your child?

What was the best time the family ever had together?

Multiple choice: Is your partner's room (a) very neat; (b) okay; (c) a federal disaster area; (d) I don't know—I can't even stand to look in there.

23

DATING TIPS FOR FEMALE GIRLS AND MALE GUYS

Idea:
A comedy for teenagers.

Cast:
 The Male Guy
 The Female Girl
 Narrator (off-camera)
Note: This movie may be made with as few as three or as many as seven or more kids. To increase the number of performers, have various kids (of either sex) take on the part of The Female Girl and The Male Guy in this script, adapting the dialogue if necessary.

Crew:
One camera operator.

Production Notes and Pointers:
 (1) Three special effects are required for this movie, two of which are explained step by step in Chapter 18. Refer back to that text for details as the script indicates.

(2) The following props are necessary:

Three cotton swabs

A deck of playing cards

A TV set

A package of individually wrapped American cheese slices labelled "singles"

An artificial drinking glass made from ice (See Chapter 18)

Place settings for dinner for two

Shooting Script:

SHOT: Very, very slow pan from the left, showing a sofa, then The Male Guy sitting on it, facing right and throwing kisses off-camera. Keep panning smoothly till you see that The Male Guy has his arm around a TV set, and that's what he's kissing. During this shot, have someone off-camera say the following narration, timing it so the phrase "video dating" is spoken precisely as the TV set appears in your shot.

<div align="center">NARRATOR</div>

If you've tried . . . video dating . . .

SHOT: The Female Girl seated at a kitchen table, holding up the package of cheese "singles."

<div align="center">NARRATOR</div>

If you've tried . . . the singles scene . . .

SHOT: The Male Guy swinging some playing cards—all clubs—in his hands.

<div align="center">NARRATOR</div>

If you've tried . . . swinging clubs . . . then you need . . .

SHOT: The Female Girl and Male Guy together, speaking the following phrase in unison with the narrator:

<div align="center">ALL</div>

. . . Dating Tips for Female Girls and Male Guys.

SHOT: Close-up of one cotton swab shown vertically like the number one. This shot serves as a title graphic.

<div align="center">NARRATOR</div>

Tip Number One . . .

SHOT: The Female Girl and The Male Guy seated together over a meal, supposedly at a restaurant. To make the setting seem realistic, play some easy-listening music and have some kids mumble and softly clang silverware in the background. The Guy is holding a drink—but the glass is really made of ice. (See Chapter 18 for instructions on how to create this prop.) He finishes drinking the liquid inside during the following narration, and as soon as the narrator finishes he chomps into the glass and gobbles up a chunk of it.

NARRATOR

Guys—when you're on a dinner date, don't make a pig of yourself.
Girls get turned off when a guy eats everything in sight.

SHOT: Close-up of two cotton swabs positioned like the Roman numeral II.

NARRATOR

Tip Number Two . . .

SHOT: Before taping this shot, position a table against a plain wall (of any color). Have The Male Guy lie *on his side* on the table, with his head hanging over the edge, facing the camera. He might want to put his hands behind his head to make the position look as casual as possible. Now, turn the camera *sideways* and come in for a medium close-up of The Guy, so he looks right-side-up *in the viewfinder*. Do not show any of the table. Leave space in the frame for The Girl to enter without your panning or cutting. Roll tape.

NARRATOR

Before you make a date, be sure you have something in common
with the boy or girl. For instance, try to find a date with the same
gravitational pull.

SHOT: The Girl moves into frame with her body upright and normal in relation to the real room but at a 45-degree angle in relation to The Guy. When you play this sequence later, she's the one who will seem out of whack, appearing to defy gravity by entering the frame sideways.

THE MALE GUY

Hi there. You come here often?

THE FEMALE GIRL

Not really. I'm not the type of girl who usually comes to planets like this.

SHOT: Close-up of three cotton swabs positioned like the Roman numeral III.

<div align="center">NARRATOR</div>

Tip number three . . .

SHOT: For this sequence, follow the step-by-step instructions for rear projection outlined in Chapter 18. The scene involves the Female Girl carrying on a conversation with her conscience, a trick sequence which has to be shot in two parts, as detailed in the Chapter 18 instructions. If you shoot the scene carefully, The Female Girl will appear to be talking to her own conscience.

<div align="center">NARRATOR</div>

There are many situations in many dates when it's hard to know exactly what to do. But always let your conscience be your guide.

<div align="center">THE FEMALE GIRL</div>

Hey—I recognize you from before I became a teenager. Who are you?

<div align="center">CONSCIENCE</div>

I . . . am your conscience.

<div align="center">THE FEMALE GIRL</div>

I can't see you very well. You look real fuzzy.
(Note: When you play this sequence, the image of the conscience will in fact appear very fuzzy, owing to the inherent drawbacks of shooting directly off the TV screen.)

<div align="center">CONSCIENCE</div>

Obviously, you don't have a very clear conscience.

<div align="center">THE FEMALE GIRL</div>

What do you want, anyway?

<div align="center">CONSCIENCE</div>

I came to be your *guide*. So let's start. This is the living room. Down the hall to the left is the kitchen. And right past that, you'll find the stairway leading to the master bedroom. And beyond that . . .
(Fade to black)

24

KIDS FROM SPACE

Idea:

A science-fiction special-effects extravaganza.

Cast:

 Earth Girl (or boy)
 Earth Boy (or girl)
 Space Girl (or boy)
 Space Boy (or girl)

Crew:

One camera operator; one special-effects director.

Production Notes and Pointers

This project requires a variety of props:

 Space Costumes—Concocted from odd household materials such as aluminum foil, old sheets or mom and dad's old love beads and bell-bottoms.

 An unusual article of Earth Kids' clothing.

 Bubble Gum—Brightly colored.

 A Flashlight—Covered with foil, colored tape or spacy-looking contact paper, perhaps with a sheet of tinted acetate over the lens.

A record, cassette or CD player, or a radio.

Two containers of juice with the labels scraped off.

Recorded video cassettes—You'll need two. One is a tape of five minutes of "Wheel of Fortune" or another ridiculous show, starting with a commercial. The other tape will have to be shot in advance with your camera. It's a close-up shot of the Space Kids in costume. The shot should be out of focus for ten seconds, then sharp for another ten seconds. For the latter period, the Space Kids should be staring at the camera saying, "Beedeebeedeebeedee . . ."

Shooting Script:

SHOT: Earth Girl confusedly fiddling with a VCR. Next to the machine are two sheets of paper with complicated numbers and letters scribbled all over them.

<div align="center">

EARTH GIRL
(Shouting to someone off-camera)

</div>

Hey, I can't figure out how to program the tuner-timer of this VCR. What am I supposed to do?

<div align="center">

EARTH BOY
(From off-camera)

</div>

You're supposed to leave me alone! That's why I wrote out all the programming instructions—they're on a piece of paper right next to the VCR.

SHOT: The Earth Girl notices that there are two pieces of paper, not one, and she picks them both up.

<div align="center">

EARTH BOY
(Still off-camera)

</div>

But be careful! My science homework is there, too. And it's the mathematical formula for infinite travel through time and space. Whatever you do, don't mix up the two pieces of paper!

<div align="center">

EARTH GIRL
(Glancing over the papers skeptically)

</div>

Oh, a tuner-timer or time and space. What's the difference. Now, let's see . . .

SHOT: She starts to program the VCR, using the wrong instructions. She

presses a lot of buttons, and soon a vague image appears on the TV screen. This is the out-of-focus part of the short tape of the two Space Kids you made in advance. Shoot the following sequence carefully, and it will appear as if the aliens came to Earth through the TV set.

EARTH GIRL

Hey, I'm good at this. I'm getting a picture already, and the show I want to record isn't even on till Thursday.

SHOT: Close-up of the TV screen, showing the fuzzy image. Let the tape play until the clear image comes on, showing the Space Kids saying, "Bee-deebeedeebeedee . . ."

SHOT: Close-up of the Earth Girl, looking slightly confused.

EARTH GIRL

What a minute. Something's funny here.

SHOT: Close-up of the TV screen, with the two Space Kids saying "Bee-deebeedeebeedee . . ." in person, *in front of the set.*

SHOT: Close-up of the Earth Girl, screaming and waving her arms in terror.

EARTH GIRL

Aaaaaaah! Somebody help me, quick!

SHOT: The two Space Kids standing in front of the TV set, facing the Earth Girl eye-to-eye. Suddenly, the Earth Boy runs into the scene.

EARTH BOY

Look what you did now. You programmed the formula for infinite travel through time and space into the VCR, so these aliens were transported through the galaxy into our TV set. And we didn't even ask mom. They'll probably leave anti-matter all over the rug.

EARTH GIRL

Don't worry. I have an idea. I'm sure they're perfectly normal and nice, even though they're unbelievably weird-looking. All we have to do is show them that we're nice, too, and we can make friends. Let's play some music for them, and we can all party.

SHOT: The Earth Girl puts on Motley Crue, Twisted Sister or something equally ear-shattering. As soon as the music starts, the Space Kids hop up in fright, make loud alien noises of fear, and lie down on their backs with their hands covering their ears. Make certain that when they fall, there's a plain, solid background (of any color) behind them.

Turn off the camera, and have the Space Girl *stand up* against the same plain, solid background in front of which she was just lying. Then turn your camera *sideways*, and get the Space Girl in the same position as her lying posture, with her hands over her ears. Your shot should show her from head to waist, but no further. Now start taping, holding the camera sideways. Do not move the camera to follow the action. The Space Girl tosses a stick of bubble gum into her mouth, blows a bubble and baby-steps for a few steps, being very careful to move her torso as little as possible. When you play this sequence later, the Space Girl will seem to defy gravity and rise straight up in the air.

SHOT: Repeat the above trick shot with the Space Boy.

SHOT: The Earth Boy gazes up at the Space Kids, who are out of frame.

> **EARTH BOY**
> I guess our music scared them. They're trying to float away with anti-gravity bubble gum. We've got to get them down and show them that we're friends. Let's give them a gift of friendship. Look, here's something nice.
> (He finds some unusual article of kids' clothing, such as studded leather socks.)
> Yo, up there. We want to be space-friends. Here, this is for you.
> (He tosses the clothing up toward the Space Kids, and we immediately hear the same alien cries of fear that the rock 'n' roll had prompted.)

SHOT: The floor, empty. Then, plop—the Space Kids land back on the ground. To do this, have them jump off a chair into frame. Trembling with fear, the Space Boy pulls his Force-Field Ray out of his back pocket (or belt or whatever).

SHOT: The acting has to be half-decent here. The Earth Boy is standing a few feet from the closest wall, when—zap—the Force-Field Ray hits his body. Suddenly, by great pantomime performance, the ray seems to hurl him flat against the wall, riveting him to the surface. (Trust me. They did this exact trick with a flashlight on *Tom Corbett, Space Cadet*, and it looked fantastic.)

SHOT: The Earth Girl implores with the Space Girl and Boy, the latter of whom is still pointing his Force-Field Ray off-frame at the Earth Boy.

EARTH GIRL

You don't understand. We want to be friends. Chill out, have a seat, and we'll get to know each other. I'll turn on the TV.

SHOT: The Earth Girl turns on the TV—actually, the tape of *Wheel of Fortune* set up in advance. It starts out with a commercial, which terrifies the Space Kids even more than the music and the clothing had. In panic, the Space Boy drops his Force Field Ray, and both Space Kids reach into their costumes for their containers of Invisibility Juice. They down the stuff and—poof—they disappear. To achieve the effect, put the camera on a tripod or a flat surface when you shoot the Space Kids guzzling the Invisibility Juice. Stop tape, have the Space Kids move out of frame, roll tape again, and they've disappeared.

SHOT: The Earth Kids in disbelief.

EARTH BOY

Gee, they drank some kind of space juice, and they're gone. I guess we're just too different from the Space Kids to be friends. We don't seem to have anything in common. Oh well, back to reality.

SHOT: The Earth Kids settle down to finish "Wheel of Fortune" when the Space Kids reappear next to them as suddenly as they disappeared. Do this the same way you made them disappear, by stopping and starting the camera.

SHOT: All the kids watching TV together.

SPACE GIRL AND SPACE BOY

Beedeebeedeebeedee . . . Oh boy! "Wheel of Fortune"!
(Fade to black)

25

MORE IDEAS

The Adventures of Superkid

A costumed hero's secret identity is *your kid*. Have him or her save the day, and not necessarily by beating the wits out of a bad guy. Think of a predicament that might instill values other than violence and aggression, such as helping a lost and frightened toddler get back home.

It's a Dog's Life

Someone spills a weird concoction of food into the dog's bowl, and when the dog drinks it he turns into a kid (by way of the old stop-start camera trick; see Chapter 18). Nobody saw what happened, but everybody can tell there's something funny about that kid. He acts exactly like a dog.

Tapercise

A customized home workout tape starring the kids, organized and supervised by their parents. Good for replaying every day as home video motivation for regular exercise.

The Neighborhood Video Club

Like a local "TV Magazine," this project includes a variety of weekly contributions from families in the neighborhood. Each segment tells a five- or ten-minute news or feature story about something of interest in that family's life during the past week. Using two VCRs, the tapes are compiled into one program for all the families to see together.

The Kids' Own Fashion Show

Kids have never been so fashion-conscious at such young ages. If they'd like, why not let them show off their stuff? Preteen girls, who otherwise tend to avoid home movies, will probably love this particular project, or at least the dressing up for it.

The Pennebaker Family Album

Named for D.A. Pennebaker, the documentary filmmaker who invented and shot (and is still shooting, as a matter of fact) one of the all-time most wonderful home movie projects. Starting in his son's first year, he's been shooting ten minutes or so of footage in his house once a year at exactly the same date and time. The kid's not a kid anymore, and Pennebaker now has hours of footage that comprise about the most unique document of an individual's life I can imagine.

GLOSSARY:
COMMON VIDEO MOVIEMAKING TERMS

Aperture: Feature of a camcorder or camera controlling the amount of light passing through the lens. The openness of the aperture is expressed in *f-stops*, although most models of video equipment have automatic apertures, usually called *auto irises*; some have limited aperture control, or *iris lock*.

Auto focus: Technology that automatically focuses a camcorder or camera on the dominant object in the viewfinder. Frequently useful but problematic when framing subjects in the sides or corners of the frame.

Battery: Rechargeable, portable power source for camcorders and portable VCRs. (Video cameras are powered by portable VCRs.) Size, weight, configuration and longevity of batteries vary among brands, formats and models of equipment. Generally, video batteries are constructed of compounds of either lead-acid or the longer-lasting and more expensive nickel-cadmium.

Beta: The first home camcorder format and the first major format of VCRs using half-inch tape.

Boom Microphone: Sensitive, directional mike that extends like a wand on top of a camera or camcorder. Valuable in cutting down ambient noise.

Burn-In: Residual image resembling a negative that remains in view after a camera or camcorder with a pickup *tube* has been exposed to a direct light source such as an incandescent bulb or the sun. Also called *image rentention* or *lag* (when involving moving hotspots).

Camera: In *video* moviemaking, the device that captures both sound and images for recording on tape by a *separate* videocassette recorder, which is attached to the camera with a flexible cable. Not to be confused with a *camcorder* (see below).

Camcorder: Combination camera and recorder—the easier, more popular gadget for shooting video home movies.

CCD: Charge-coupled device—internal component that "picks up" or "senses" images on a camera or camcorder. One of two major types of solid-state *pick-ups* (or *sensors*), as opposed to tubes. Not as sharp and clear as tubes, but less susceptible to *burn-in* and *lag*.

Character Generator: Accessory for electronically generating words and numbers on a tape. Some camcorders and most video cameras feature built-in character generators, or titlers.

Chrominance: Color.

C-Mount: Screw-in lens mount common on older video cameras. Highly regarded among video enthusiasts for its ability to accept conventional 35-mm still-camera lenses.

Color Temperature: Expression of the effect that the temperature of light has on color, expressed in degrees Kelvin. Lower color temperatures (as with fluorescent lights) increase blueness; higher color temperatures (as with tungsten lights) increase redness.

Condensor Microphone: Nondirectional, general-purpose mike built into most cameras and camcorders.

CRT: Cathode-ray tube—standard picture tube used both in TV sets and in the electronic viewfinders of cameras and camcorders.

Depth of Field: Distance between the closest and farthest points *in focus* through a lens. The higher the f-stop setting (meaning the lesser the amount of light getting through) of a camera or camcorder, the greater the depth of field.

Dew Control: Internal element that automatically shuts off a camcorder or VCR in the event of extreme humidity.

Digital: High-performance technique of recording sound by computerization of audio sound information, possible with some 8-mm video equipment. Separately, in terms of home VCRs and TV sets, digital circuitry processes pictures to enable such tricks as picture-in-picture and freeze-frame during TV broadcasts.

Drop-Out: Partial break-up of picture visible during playback of video tapes, commonly caused by inferior tape quality, worn-out tape or clogged camcorder or VCR heads.

Dubbing, Audio: Means of replacing previously recorded sound on a videotape without affecting the picture. Possible with virtually all VCRs and some camcorders.

Dubbing, Video: Method of retaping both audio and video material by use of two VCRs or one VCR and a camcorder (if that camcorder has either input or output jacks). The new recording is called the *dub*. (See *editing*, below.)

Editing: Process of organizing the sequence of images and sound on a cassette, performed by dubbing from one VCR or camcorder to another.

8-mm: The home video format that employs the smallest tape, 8-millimeters in diameter. Most popular for moviemaking applications but also applicable for recording TV programs and playing prerecorded programs such as popular movies. In addition, some 8-mm video equipment can record *digital audio*. The 8-mm video format has no relation to 8-mm or super-8 film, aside from the size of the medium.

Frequency Response: Resolution or detail-resolving ability of a VCR or camcorder. The better the frequency response of both the recording equipment and the tape involved, the more detail discernible during playback.

F-Stop: Number, usually expressed in a fraction (such as 1.4, 2.8), representing the amount of light entering a lens. The lower the f-stop number, the greater the amount of light.

Field: While film creates the illusion of movement by use of 24 individual still *frames* per second, video uses *fields*, traced onto the TV screen one

line at a time, from top to bottom. By U.S. standards, one field is 262.5 horizontal lines every sixtieth of a second.

Frame: See *field*.

Focal Length: The distance between a camera's lens and its point of "infinity" focus.

Footcandle: A measurement of the amount of light falling on a surface, used to indicate the sensitivity of a camera or camcorder. As with *lux*, the lower the footcandle rating, the lesser the amount of ambient light essential to render a discernible image.

Format: Method of video recording, such as Beta, 8-mm, or VHS. Unfortunately, all video formats are incompatible; tapes recorded in one format cannot be played on machines of any other format. However, recordings can be *re*-recorded from one format to another, for instance, from Beta to VHS.

Formulation: The type of metal-based particles on the surface of a video tape, onto which a VCR or camcorder records images and sound electromagnetically. The three main home video tape formulations are ferric oxide, chromium dioxide, and metal particle (used in the 8-mm format only).

Generation: The first video recording ever made of a real-life event is the first-generation tape of that event. A recording *of* that recording is the second-generation tape. A recording of the recording of the recording is the third-generation tape, and so forth.

Glitch: Burst of video noise or static.

Half-Inch: Width of videotape used in both the Beta and the VHS formats.

Hardware: Equipment.

Head: Internal electromagnetic component of camcorders and VCRs which comes in contact with the surface of the video tape in order to record or play sounds and images.

Head Alignment: Contact angle of camcorder and VCR heads. Improper head alignment may result in loss of picture and sound quality.

Head Clogging: Accumulation of tape particles, dust and other elements on video heads, usually responsible for poor recording and playback.

Hi-Fi: In video lingo, a particular technique for recording sound, technically called Audio Frequency Modulation (AFM).

HQ: High Quality circuitry, a merchandising term used to describe a variety of parameters related to video recording. The value of the term as a meaningful measure of performance has been a subject of debate among video enthusiasts.

Horizontal Resolution: Specification for the number of horizontal lines visible on a TV set. The higher the resolution, the sharper the picture.

Lens Speed: Representation of a lens' ability to collect light. The faster the lens, the more light it accepts.

Light Shoe: The hook-type device on top of many cameras and camcorders as well as 35-mm cameras, used to attach accessories such as boom mikes and lights.

Luminance: Brightness.

Lux: Like *footcandles*, a measurement used to represent the sensitivity of a camera or camcorder. The lower the lux rating, the better.

Macro: Close-up setting on a lens.

Maximum record length: A designation for the amount of material that can fit on a cassette, usually indicated in minutes. A function of recording speed (or mode, such as standard play, long play, and extended play) and tape length. Typical options are 60-, 120- and 160-minute lengths.

Minimum Focus Distance: As with film cameras, the minimum distance at which a subject can be captured in proper focus without the use of accessory lenses.

Minimum illumination: The lowest amount of light necessary to produce a viewable image with a camera or camcorder, represented in footcandles or lux.

Monochrome: Black-and-white. In video, unlike film, the ability to shoot in color or black-and-white is entirely a function of the equipment, not the tape. Initially, all home video cameras were black-and-white only; now, all are color only. As a result, older monochrome equipment has taken on value as collectors' items.

MOS: Metal Oxide Semiconductor—solid-state pickup that captures images on a camera or camcorder, like a CCD sensor.

Noise: Video or audio interference that is visible or audible as a brief interruption of the picture or sound.

NTSC: National Television Standards Committee—the U.S. color-TV broadcasting standard of 525 lines per 60-field raster (see *raster*), employed by all VCRs, camcorders and TV sets usable in the U.S. Also the standard in Canada, Japan, Mexico, and other countries. (See PAL and SECAM.)

PAL: Phase Alternation Line—a color-TV broadcasting standard of 625 lines per 50-field raster (see *raster*), superior to but incompatible with NTSC (above). Used in most West European countries, among others. Non-NTSC prerecorded cassettes purchased overseas *will not* work on U.S. equipment, although *blank tapes* may be used interchangeably among NTSC, PAL or SECAM equipment, so long as they are in the appropriate *format* (Beta, VHS or 8-mm).

Pause: Feature of camcorders and VCRs that temporarily halts videotape movement.

Pickup: The solid-state sensor or tube that translates light into electronic impulses. Today, most pickups are either CCD or MOS sensors, with one type of tube ("Newvicon") remaining. Solid-state sensors are less susceptible to damage from direct light, but tubes produce clearer, sharper images.

Playback features: The capabilities of a VCR or the "corder" section of a camcorder for playback through the viewfinder or a TV set, including forward, reverse, scan and freeze-frame.

Power: Electricity. All camcorders and portable VCRs may be powered by either batteries or AC wall current. (Video cameras are powered by portable VCRs.)

Power Pack: Accessory which drives a camcorder or portable VCR, with the benefit of supplying power for a period significantly longer than that possible with a conventional battery. Part of a power pack fits into the recording device, attached by cable to a larger section carried by belt or shoulder strap.

Power zoom: Motorized zoom control, usually with one preset speed. The most common camcorder zoom ratio is 6:1, with 8:1 and 3:1 the extremes.

Raster: Technical term for a TV-tube picture.

SECAM: Sequential Couleur à Memoire—the third type of color-TV broadcasting standard, 625 lines per 50-field raster (see above). Used in the Soviet Union, most East European countries, and France, among others.

Shot: Any individual sequence of video footage, from the point of initiating recording to the point of stopping tape.

Signal-to-Noise Ratio: Specification for the amount of visible or audible noise in a video recording, determined by the performance of the camcorder or VCR as well as the blank tape.

Software: Tape.

Special Effects: Any of many camcorder or VCR playback features, such as slow motion, freeze-frame, and scan.

Titles: Words or numbers appearing in a movie, whether shot optically or rendered electronically, as some camcorders and most video cameras are capable of doing.

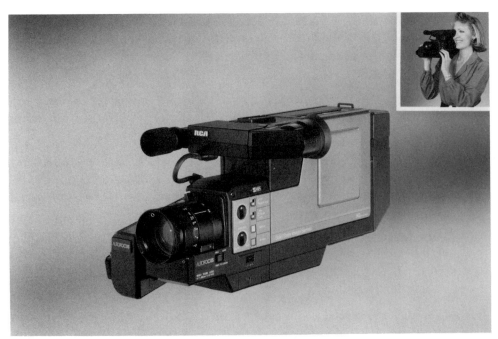

VHS, full-size: RCA's Super-VHS camcorder.

Tracking: The process within a camcorder or VCR wherein the videotape passes over the heads in precise alignment. The tracking control alters head position microscopically to help clear up noise caused by improper alignment.

Tripod: Adjustable camera stand that rests on three legs.

Tuner/Timer: Product common before the proliferation of camcorders, used in conjunction with a portable VCR for recording TV programs.

VCR: Video cassette recorder.

VHS: Video Home System—the more popular of the two half-inch VCR formats, the other being Beta.

Viewfinder: Either optical or electronic, the small window on a camera or camcorder through which moviemakers view what they're recording.

White Balance: Specification for the ability of a camera or camcorder to reproduce white tones accurately.

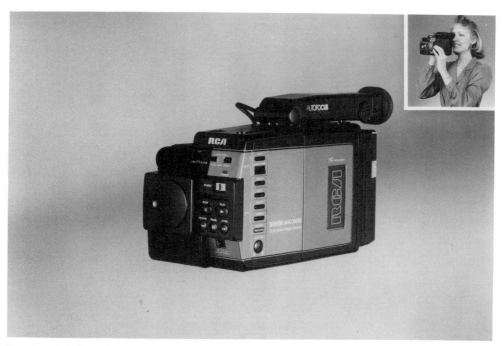

VHS, mini: RCA's Super-VHS-C camcorder.

Wireless Microphone: Two-part accessory mike, one part of which is hooked onto the light shoe of a camera or camcorder, the other part of which clips onto a subject's clothing. Allows recording of voices over fairly long distances or in noisy environments.

Zoom Lens: A lens adjustable to a range of focal lengths. All video cameras and camcorders available since the early 1980s incorporate zooms, most electronically adjustable by use of a *power-zoom* control.

INDEX

About the Author

DAVID HAJDU has published both fiction and non-fiction on subjects as diverse as film, music, advertising, food, and cultural philosophy, as well as parenting and technology. His articles have been published in *Newsweek*, *The New York Times*, *Playboy*, *TV Guide*, and many other publications, and have appeared in five languages around the world. The editor of *Video Review* from 1982 to 1985, Hajdu also edited the book *Video Review's Best on Home Video*. He attended New York University, and teaches part-time at Parsons School of Design. Hajdu lives in New York City with his wife, Joanne Simbal Hajdu, an author of novels for young people, and their two children, Victoria and Jacob.

Parenting and Child Care Books Available from Newmarket Press

Lynda Madaras Talks to Teens About AIDS
An Essential Guide for Parents, Teachers, and Young People
by Lynda Madaras

Written especially for parents, teachers, and young adults aged 14 through 19, this valuable book describes with honesty and sensitivity what AIDS is, why teens need to know about it, how it is transmitted, and how to stay informed about it. Includes drawings, bibliography, resource guide. (96 pages, 5½ × 8¼, $11.95 hardcover, $4.95 paperback)

Lynda Madaras' Growing Up Guide for Girls
by Lynda Madaras with Area Madaras

For pre-teens and teens; an all-new companion workbook/journal to the *What's Happening to My Body? Book for Girls* to help girls further explore their changing bodies and their relationships with parents and friends; complete with quizzes, exercises, and space to record personal experiences. Includes drawings, photographs, bibliography. (256 pages, 7¼ × 9, $16.95 hardcover, $9.95 paperback)

The "What's Happening to My Body?" Book for Boys
A Growing Up Guide for Parents and Sons NEW EDITION
by Lynda Madaras, with Dane Saavedra

Written with candor, humor, and clarity, here is the much-needed information on the special problems boys face during puberty, and includes chapters on: changing size and shape; hair, perspiration, pimples, and voice changes; the reproductive organs; sexuality; and much more. "Down-to-earth, conversational treatment of a topic that remains taboo in many families"—*Washington Post*. Includes 34 drawings, charts, and diagrams, bibliography, index. (272 pages, 5½ × 8¼, $16.95 hardcover, $9.95, paperback)

The "What's Happening to My Body?" Book for Girls
A Growing Up Guide for Parents and Daughters NEW EDITION
by Lynda Madaras, with Area Madaras

Selected as a "Best Book for Young Adults" by the American Library Association, this carefully researched book provides detailed explanations of what takes place in a girl's body as she grows up. Includes chapters on: changing size and shape; changes in the reproductive organs; menstruation; puberty in boys; and much more. Includes 44 drawings, charts and diagrams, bibliography, index. (288 pages, 5½ × 8¼, $16.95 hardcover, $9.95 paperback)

How Do We Tell the Children?
Helping Children Understand and Cope When Someone Dies
by Dan Schaefer and Christine Lyons; foreword by David Peretz, M.D.

This valuable, commonsense book provides the straightforward language to help parents explain death to children from three-year-olds to teenagers, while including insights from numerous psychologists, educators, and clergy. Special features include a 16-page crisis-intervention guide to deal with situations such as accidents, AIDS, terminal illness, and suicide. "Parents need this clear, extremely readable guide . . . highly recommended"—*Library Journal.* (160 pages, 5½ × 8¼, $16.95 hardcover, $8.95 paperback)

Your Child At Play: Birth to One Year
Discovering the Senses and Learning About the World
by Marilyn Segal, Ph.D.

Focuses on the subtle developmental changes that take place in each of the first twelve months of life and features over 400 activities that parent and child can enjoy together during day-to-day routines. "Insightful, warm, and practical ... expert knowledge that's a must for every parent" (T. Berry Brazelton, M.D., Boston Children's Hospital). Includes over 250 photos, bibliography. (288 pages, 7¼ × 9, $16.95 hardcover, $9.95 paperback)

Your Child at Play: One to Two Years
Exploring, Daily Living, Learning, and Making Friends
by Marilyn Segal, Ph.D., and Don Adcock, Ph.D.

Contains hundreds of suggestions for creative play and for coping with everyday life with a toddler, including situations such as going out in public, toilet training, and sibling rivalry. "An excellent guide to the hows, whys, and what-to-dos of play . . . the toy and activity suggestions are creative and interesting"—*Publishers Weekly.* Includes over 300 photos, bibliography, index. (224 pages, 7¼ × 9, $16.95 hardcover, $9.95 paperback)

Your Child at Play: Two to Three Years
Growing Up, Language, and the Imagination
by Marilyn Segal, Ph.D., and Don Adcock, Ph.D.

Provides vivid descriptions of how two-year-olds see themselves, learn language, learn to play imaginatively, get along with others and make friends, and explore what's around them, and uses specific situations to describe and advise on routine problems and concerns common to this age, especially that of self-definition. Includes over 175 photos, bibliography, index. (208 pages, 7¼ × 9, $16.95 hardcover, $9.95 paperback)

Your Child at Play: Three to Five Years
Conversation, Creativity, and Learning Letters, Words, and Numbers
by Marilyn Segal, Ph.D., and Don Adcock, Ph.D.

Hundreds of practical, innovative ideas for encouraging and enjoying the world of the preschooler, with separate sections devoted to conversational play, discovery play, creative play, playing with letters and numbers, and playing with friends. Includes 100 photos, bibliography, index. (224 pages, 7¼ × 9, $16.95 hardcover, $9.95 paperback)

"Your Child at Play" Starter Set
Three paperback volumes, covering birth through three years, in a colorful shrink-wrapped boxed set. The perfect gift for parents, teachers, and care-givers. ($29.85)

How to Shoot Your Kids on Home Video
Moviemaking for the Whole Family
by David Hajdu

The perfect book for the video-age family and classroom—from the former editor of *Video Review*. Offers parents and teachers a lively, "user-friendly" look at making wonderful home-movie videos, featuring 11 ready-to-shoot scripts. Includes photos, index. (208 pages, 7¼ × 9, $21.95 hardcover, $10.95 paperback)

Baby Massage
Parent-Child Bonding Through Touching
by Amelia D. Auckett; Introduction by Eva Reich, M.D.

A fully illustrated, practical, time-tested approach to the ancient art of baby massage. Topics include: bonding and body contact; baby massage as an alternative to drugs; healing the effects of birth trauma; baby massage as an expression of love; and more. "For anyone concerned with the care and nurturing of infants"— *Bookmarks*. Includes 34 photos and drawings, bibliography, index. (128 pages, 5½ × 8¼, $8.95 paperback)

In Time and With Love
Caring for the Special Needs Baby
by Marilyn Segal, Ph.D.

From a psychologist and mother of a handicapped daughter, sensitive, practical advice on play and care for children who are physically handicapped, develop-mentally delayed, or constitutionally difficult. Topics include: developing motor skills, learning language, and developing problem-solving abilities; interacting with siblings, family members and friends; handling tough decision-making; and much more. Includes 50 photos, six resource guides, bibliography, and index. (208 pages, 7¼ × 9, $21.95 hardcover, $12.95 paperback)

Ask for these titles at your local bookstore or

Use this coupon or write to: NEWMARKET PRESS, 18 East 48th Street, NY, NY 10017.

Please send me:

Auckett, BABY MASSAGE
__ $8.95 paperback (0-937858-07-2)

Madaras, LYNDA MADARAS' GROWING UP GUIDE FOR GIRLS
__ $16.95 hardcover (0-937858-87-0)
__ $9.95 paperback (0-937858-74-9)

Madaras, "WHAT'S HAPPENING TO MY BODY?" BOOK FOR BOYS
__ $16.95 hardcover (1-55704-002-8)
__ $9.95 paperback (0-937858-99-4)

Madaras, "WHAT'S HAPPENING TO MY BODY?" BOOK FOR GIRLS
__ $16.95 hardcover (1-55704-001-X)
__ $9.95 paperback (0-937858-98-6)

Schaefer/Lyons, HOW DO WE TELL THE CHILDREN?
__ $16.95 hardcover (0-937858-60-9)
__ $8.95 paperback (1-55704-015-X)

Segal, YOUR CHILD AT PLAY: BIRTH TO ONE YEAR
__ $16.95 hardcover (0-937858-50-1)
__ $9.95 paperback (0-937858-51-X)

Segal/Adcock, YOUR CHILD AT PLAY: ONE TO TWO YEARS
__ $16.95 hardcover (0-937858-52-8)
__ $9.95 paperback (0-937858-53-6)

Segal/Adcock, YOUR CHILD AT PLAY: TWO TO THREE YEARS
__ $16.95 hardcover (0-937858-54-4)
__ $9.95 paperback (0-937858-55-2)

Segal/Adcock, YOUR CHILD AT PLAY: THREE TO FIVE YEARS
__ $16.95 hardcover (0-937858-72-2)
__ $9.95 paperback (0-937858-73-0)

Segal/Adcock, "YOUR CHILD AT PLAY" STARTER SET (Vols. 1, 2, & 3 in paperback gift box set)
__ $29.85 (0-937858-77-3)

Madaras, LYNDA MADARAS TALKS TO TEENS ABOUT AIDS
__ $11.95 hardcover (1-55704-010-9)
__ $4.95 paperback (1-55704-009-5)

Hajdu, HOW TO SHOOT YOUR KIDS ON HOME VIDEO
__ $21.95 hardcover (1-55704-014-1)
__ $10.95 paperback (1-55704-013-3)

Segal, IN TIME AND WITH LOVE
__ $21.95 hardcover (0-937858-95-1)
__ $12.95 paperback (0-937858-96-X)

For postage and handling add $1.50 for the first book, plus $.75 for each additional book. Allow 4-6 weeks for delivery.

I enclose check or money order payable to NEWMARKET PRESS in the amount of $_____.

NAME _____

ADDRESS _____

CITY/STATE/ZIP _____

For quotes on quantity purchases, or for a copy of our catalog, please write or phone Newmarket Press, 18 East 48th Street, NY, NY 10017. 1-212-832-3575.